Leading Roles

Leading Roles

50 Questions Every Arts Board Should Ask

MICHAEL M. KAISER

BRANDEIS UNIVERSITY PRESS

Waltham, Massachusetts

Published by

University Press of New England

Hanover and London

BRANDEIS UNIVERSITY PRESS

Published by University Press of New England

www.upne.com

© 2010 Brandeis University

All rights reserved

Manufactured in the United States of America

Designed by Richard Hendel

Typeset in Arno and Scala Sans by Passumpsic Publishing

University Press of New England is a member of the Green Press Initiative.
The paper used in this book meets its minimum requirement for recycled paper.

For permission to reproduce any of the material in this book, contact
Permissions, University Press of New England, One Court Street, Suite 250,
Lebanon NH 03766; or visit www.upne.com.

Library of Congress Cataloging-in-Publication Data

Kaiser, Michael M.

Leading roles: 50 questions every arts board should ask / Michael M. Kaiser.
— 1st ed.

 p. cm.

ISBN 978-1-58465-906-8 (cloth : alk. paper)

1. Arts boards — United States. 2. Arts — United States — Management.
I. Title. II. Title: 50 questions every arts board should ask. III. Title: Fifty
questions every arts board should ask.

NX765.K35 2010

700.6 — dc22 2010018782

5 4 3 2

In memory of SUSAN KAISER,

a spectacular not-for-profit executive

Contents

BOARD AND PROGRAMMING

Apology

The concepts and ideas in this book have been developed over a twenty-five-year career in arts management. It is clearly *not* a scholarly work. There are no sources of information identified, no footnotes, and no index. I have stolen ideas liberally throughout my career from the many talented and thoughtful arts managers I have met and observed. I give them no formal credit in this book, but their contributions to this young field of arts management are invaluable. Many talented practitioners disagree with me on many of my answers to the questions included in this book. Any thoughtful board member will want to read other works on similar topics.

No one can disagree that a healthy arts organization requires open channels between board, artistic staff, and executive staff. Although this book is primarily intended to help volunteer board members enjoy their governance roles, this necessitates addressing the key responsibilities of artistic leaders and executive directors, as well.

Because of the question-and-answer nature of this book, I have repeated some information in several answers, so that the reader of an individual question gets a thorough response. I apologize for this repetition.

Finally, it is far easier to communicate the challenges of being a good board member than the joy of participating in a fruitful endeavor that creates great beauty and enriches a community. While the requirements for creating and governing a successful arts organization are easy to delineate, they are not easy to implement. I have failed as often as I have succeeded. This book presents an ideal that is rarely achieved. Despite occasional failures, great art and education are still produced, and board members find great satisfaction in their involvement. I just want to make it easier, more fun, and more consistently rewarding.

Acknowledgments

While it may take a village to raise a child, it takes a large group of friends and colleagues to write a book. I am deeply indebted to my staff at the John F. Kennedy Center for the Performing Arts for their support, guidance, and forbearance. I must single out Darrell Ayers, Scott Bushnell, John Dow, and David Kitto for their tremendous assistance. And special thanks go to the director of the DeVos Institute of Arts Management at the Kennedy Center, Brett Egan, and my dear friend, Tiki Davies, for reading several drafts of this manuscript and making important comments and criticisms. While they have made many improvements, the errors that remain are my responsibility alone.

Introduction

When I teach arts management seminars outside the United States, I am always greeted with a wave of jealousy about American boards of directors. Foreign arts managers want boards to give huge contributions, solicit all of their friends, and support the work of the staff, as they perceive American arts boards do. They would be happy to replace their existing board members, whom they consider overseers without the passion and involvement of American board members. They are convinced that boards of American arts organizations make the work of the arts managers very easy.

Of course, in my experience, this dream of an American board hardly matches the reality. I typically entered struggling organizations that were in danger of going bankrupt. My boards were divided, divisive, and often angry.

My personal history with boards of arts organizations began in 1983, when I was asked to serve on the board of The Washington Opera (now the Washington National Opera). Like most people who become board members, I joined with great intentions and with the expectation that I could make a difference. I knew I had the desire to be generous with time and resources. That I knew nothing about opera production, had never been involved with an arts organization, and had never served on a board before did not deter me. I knew I loved opera and was an experienced business manager, and I figured that was all I needed.

Like so many board members, I grew disenchanted over time. I found that I wanted to be more involved on a day-to-day basis than was appropriate for a board member. I continually "poached," trying to make the decisions that were more appropriate for staff members to make. I realized I wanted to be a staff member, not a board member. This is why I ultimately left the board, sold my consulting business, and entered the world of arts management.

But there are many other reasons why board members become disenchanted: Many don't like the leadership of the board. They feel the board chair is too powerful, or not engaging enough, or not generous enough.

They chafe at the notion of having to work under someone they neither respect nor consider a peer.

Others find that the art does not excite them. They feel the art is too daring or too old-fashioned, or simply not good enough. They are embarrassed to invite their friends and associates to events and performances but know they are expected to do so. This tension causes them either to quit the board or to find excuses for not bringing others to events; these excuses can often be highly divisive.

A good number of board members feel the staff is not competent. They believe that if only the staff members were smarter or more creative or harder working, the organization would be in a better situation. (Of course, many staff people believe that if only the board were more involved, more generous, and more helpful with fundraising, then the organization would be in a better situation.)

Too often board members feel under-appreciated. They are asked to make contributions, come to meetings, and join committees, but are rarely thanked. They feel that only the wishes of the biggest donors are catered to and that their own contributions are not substantial enough to warrant attention. Many of these board members depart to find organizations where they can be the "big fish."

Some board members do not understand the duties and responsibilities of being on a board and, after weeks or months of "drifting at sea," they simply give up. They are uncomfortable sitting on a board and not understanding why they are there or how they are supposed to behave.

A large number of board members believe they are only wanted for their annual contributions. Once they write their checks, they are ignored. They want to be more involved in decision making and managing the organization but feel that they are not "allowed in."

The largest contingent of unhappy board members is nervous about the financial condition of the organization. They are frustrated by the lack of cash to pay bills and make payroll, and are not certain how to solve the problem that seems to persist and that often grows more serious over time. They feel a moral responsibility to help (and fear their legal liability), but they simply do not know what to do.

And some board members just do not understand the financial statements. Even some people with substantial for-profit experience have difficulty with the financial statements of not-for-profit organizations. This

can lead to feeling cheated, or lied to, even when there is nothing illicit going on.

Too many people join boards without really understanding and accepting the mission of the organization. They either think they know the mission, or they assume they can influence the mission; this can lead to a schism with the artistic leadership of the organization and a belief that the staff "never take my suggestions."

And finally, many board members have not been trained to serve on an arts board and have no idea what creates success for the organization. They want to be helpful but do not know or understand the true keys to success.

When any of these feelings obtain, board members become unhappy. At best, they withdraw and, at worst, they create problems.

I was in the latter category at The Washington Opera. I kept telling every board member and staff member that I knew better than they how to run the organization; I was a true nuisance. Martin Feinstein, the general director, was incredibly patient with me. (Martin wrote me the loveliest note when I became head of the Royal Opera House years later; he noted that "I asked many questions" when I was on his board—a true understatement.)

Though I was young and callow at the time, it was a shame that I could not have been more helpful to the organization. In retrospect, I know I had a lot to offer, but I withdrew out of frustration (of my own making, of course). As a result, the overwhelming feeling I have when I hear about unhappy board members is sadness at a lost opportunity.

Happy boards have an astonishing power to be supportive — emotionally, strategically, and financially. I believe that the way the board of a not-for-profit arts organization functions is a barometer of the health of the institution. Institutions that create great art regularly, market themselves aggressively, build their constituencies, and earn operating surpluses typically have boards that are well governed, maintain strong relationships with staff, find new leadership when needed, and have members who feel both empowered and satisfied. The members of these boards find great fulfillment in being part of something meaningful to themselves and to their communities.

A strong board provides the staff with a set of partners who truly share the burden of difficult decisions and also the joy of achievement and

success. The happy board continuously brings new friends to the organization — a requirement for success. A healthy not-for-profit organization must continuously attract new members to its "family," and a successful board is central to this activity.

Unhappy boards rarely bring new people to the organization.

When I joined the Alvin Ailey American Dance Theater as the executive director in 1991, it was nearly bankrupt. The board was exhausted from seeing the company through a series of financial and managerial crises. When I met with each board member individually to ask who they knew who could help us, not one board member knew another living soul! As a result, one of the central powers of a board — to bring new friends to the organization — was not being realized.

It was only after the Ailey organization was doing better financially and had established a stronger public profile that our board members were willing to bring their friends and associates into the fold. In the process, the board underwent a major restructuring: half of the board members had left or been removed. They had been replaced with new members, who had the power to contribute and to raise the funds needed for an organization of our size and scope. I learned that one of my jobs as a manager is to make my board members so excited about our success that they feel compelled to introduce me to their friends.

This book is intended to help members of boards and staffs create the healthy, happy atmosphere that is required for a thriving arts organization. I hope the answers help many board members increase their level of enjoyment and, hence, productivity.

The questions I include have all been asked of me at the board seminars the Kennedy Center mounts in Washington, D.C., and in cities across the United States. I am indebted, therefore, to the board members who attend; they are passionate devotees of their organizations and want to see them function more smoothly. (Ironically, they are the board members least in need of training!) It is to these passionate and involved trustees, the ones my foreign students assume are typical of American board members, that I dedicate this book.

Leading Roles

Life Cycle

I HOW DOES A SUCCESSFUL ARTS ORGANIZATION FUNCTION?

Before one can discuss the role of the board, the way board members should interact with administrative and artistic staff, and the way to evaluate marketing, fundraising, and financial plans, it is essential to understand what makes an arts organization run successfully.

Many individuals join boards, confident that they understand the requirements for success in the arts, but arts managers usually have their own views on the subject. The root cause of the schism that often develops between board and staff is a fundamental disagreement over the prerequisites for the smooth functioning of an arts organization.

The operations of all truly successful arts organizations follow the same simple model: they create wonderful, innovative, and surprising artistic and educational programming, and they market themselves well and aggressively. The combination of great programming and great marketing attracts an ever-growing constituency of audience members, volunteers, donors, and board members. This growing "family" then produces increased revenue, both earned and contributed, which is invested in further excellent programming, which is marketed energetically, and so on. The family members of arts organizations in this happy cycle can feel and appreciate their good fortune. They may not know why it is a pleasure to be associated with the group, but they know they are part of a winning enterprise.

Unfortunately, this is not an easy situation to create or to maintain. It takes artistic leaders who know how to make or present interesting and important art; however, these are a precious few. There are too many arts leaders who do not have the skills to produce excellent work; there are even more who would rather follow the audience's tastes than develop them.

Many artistic directors have been so sensitized to the financial concerns

of their organizations that they have forgotten how to be truly creative; they approach each season as a series of slots to be filled, rather than as opportunities to express creative thoughts. Too often, the organization does not support artistic experimentation or accept that some percentage of the work created may fail. Great artists all have failures; the trick is to budget and plan for some failure each season, so that if and when it comes, it does not leave a huge hole in the organizational budget.

It takes executive directors and administrative staffs that know how to do the marketing, fundraising, and financial management that support the vision of the artistic director. In particular, it takes a staff that can create the institutional visibility so essential for attracting more members to the family. Since there is so little money devoted to educating arts managers, there is far too small a pool of talented, trained people to fill the key jobs in arts organizations. Too often, a creative leader does not have the executive staff needed to develop the cadre of audience members and donors required to support the work.

It takes a board that embraces its roles as partner of the staff and resource developer for the institution. Many board members do not appreciate the skills, training, and talents of their artistic and administrative staffs. When board members try to do the work of the staff, virtually attempting to become staff, it almost always ends in disaster. Conversely, when a board sits back and allows the staff to operate without sufficient oversight, problems will also ensue. This is a difficult balance achieved only by the best boards, with the best leadership. In addition to this crucial internal role, the board members must also be willing to be ambassadors to their communities. They must help build allegiance to the organization, solicit resources, pursue new board members, and find other organizations with which to partner.

Successful organizations also enjoy a high level of trust and respect among these three groups: artistic leaders, staff, and board. When each group does its job well and enjoys collaborating with the other two, the organization is likely to be a success. In fact, there is a high level of interdependence in this model; the three groups do not work in silos, but must coordinate and communicate freely. The executive staff must understand the artistic plan if there is going to be a solid marketing effort; the board must understand both artistic and marketing plans to help solicit resources. Ultimately, what unites these three constituencies is a common understanding and appreciation of the mission of the organization.

When all participants are focused on the same set of goals, they are far more likely to work in unison.

This "machine" hums along happily, unless or until it is disturbed by a split in focus. When one or more participants forget that artistic and educational initiatives are at the root of the organization's success, when a decision is taken to divert too many resources from programming to other activities (including constructing a facility or creating an endowment), or when one or more of the three participants "deteriorate," the organization can quickly become dysfunctional and lose its happy equilibrium.

When this happens, the three groups begin to poach on each other's territory — the board or administrators begin to make their own artistic ideas known, and the artistic staff thinks of creating its own marketing and fundraising efforts. Mistrust develops quickly between the various participants, and the feelings of collaboration and mutual support evaporate. The board members become embarrassed about the organization and will not invite their friends and associates to join the family. The staff begins to resent the board's lack of involvement. Virtually every player believes at least some of the others should be replaced. It is the ephemeral nature of the happy equilibrium that makes it so precious and so needing protection by all participants: artists, administrators, and board members.

2 HOW DOES AN ARTS ORGANIZATION EVOLVE?

Virtually every arts organization begins as the dream of a visionary. The goal may be lofty (providing people of all backgrounds access to great art) or more personal (providing an opportunity to show their work), or some combination of the two.

Artists who decide to leap into self-production may follow very different paths, depending on two vital factors: talent and money. Great artists, at least those perceived by the world as great artists, can build an earned-income base and, eventually, a contributed-income base, as well. Artists with sufficient financial backing can "buy" some measure of success. These lucky few (and they are getting fewer and fewer each year) can establish a board of directors, receive bookings, sell tickets, and raise funds. If these fortunate individuals or organizations approach these activities in an organized manner, they can mature in a rather painless fashion.

But most artists who launch organizations do not have this bounty and must start with little acclaim and less money. They typically save up for one initial project, frequently with the support of family and friends. The project goes well, everyone offers positive feedback (except perhaps the critics, who may pay no attention whatsoever), and the artist is convinced the applause will go on forever.

Then reality sets in. All the funds were used for the first project. No one is knocking down the door to offer bookings or contributions. And the thought of going through the effort to find the resources, engage other artists, book the space, do the marketing, and create another production — with no real staff help — is daunting.

Many artists stop at this point and return to employment with an established arts organization. Others persevere and enter a critical stage in the development of their companies: they come to appreciate the non-artistic elements of arts production. Marketing, fundraising, tour booking, finance, boards of directors, and even long-term planning become real and important.

How artists cope with this set of issues will determine, in many respects, the way their companies develop. Creating a strong board that can provide and solicit funding and help address administrative requirements is crucial. Building an arts organization is expensive; without access to substantial resources of their own, artists must rely on others. Often, artists limp along from season to season, without significant growth in support, ticket sales, or artistic scope. Most start-up arts ventures become mired at this stage and then eventually evaporate from lack of funding or persistence.

The fortunate few who can attract a strong board, make an impression on critics and audiences, begin to receive support from foundations or corporations (usually through board contacts), and make it through this arid period with determination intact, will enter the most exciting phase of their organizational careers.

After several years of presentations, a well-managed, successful arts project will enjoy a level of demand, a degree of visibility, and a base of support that provide the seeds of a lasting organization. Generally at this time, gifts from individuals grow substantially, foundation support and government grants commence, and touring opportunities increase. This confluence of visibility, institutional support and earned- income growth allows the organization to flourish. The hard work of the board begins to

pay off; money flows more freely, the administrative infrastructure can be strengthened, and management looks like a group of heroes.

The euphoria of the growth period, however, can come to a crashing halt when the company has maximized its income from existing funders, the board members are no longer increasing their gifts to match the organization's budget growth, and earned income hits its peak (especially if the artistic programming loses its "edge"). At this point, many mid-career artists lose support of funders that focus on emerging artists, and are not yet competitive enough for the largest grants. Often, too, the press becomes more critical.

Suddenly, the rapid annual increase in expenses during the growth phase is no longer matched by increments in revenue. Since this turn is rarely anticipated, arts organizations at this stage typically incur one to three years of deficits. If the deficits are large enough, they can erase any accumulated surpluses and even threaten the life of the organization. The lack of a financial cushion is perhaps now most evident — the organization may be as famous as ever, but is in danger of extinction. Management is invariably blamed, the board grows frustrated, the artistic mission is ignored, and cash flow becomes the central topic of every conversation.

These problems call for substantial institutional change: improving development capability, rebuilding institutional visibility, and strengthening the board. Organizations recognizing this are in a good position to move past the crisis point. Those failing to see the need for change, or believing they can grow stronger by continuing to reduce budgets, tend to wither away.

Organizations that emerge from the crisis (and the rare few that avoid it altogether) can become viable institutions, with the board and staff to foster consistent artistic accomplishment and the earned- and contributed-income base to support program development.

These institutions are not immune to problems and must stay aware of changes in the arts environment. But with the proper mix of artistic and administrative leadership, and the oversight of a strong, continuously evolving board, these organizations have the potential to weather crises by building financial structures, including endowments, which provide long-term stability.

3 HAS OUR BOARD MATURED WITH OUR ORGANIZATION?

These stages in the life cycle of the organization must be matched by the development of the board itself. When the organization is first created, the board members are usually friends and family of the artistic visionary who founded it. Very frequently, in the absence of staff, the board members are asked to perform staff functions: bookkeeping, marketing, and even sewing costumes. These board members develop a strong allegiance to the organization and usually have a tremendous passion for its artistic programming. They become the keepers of the flame and the possessors of institutional memory.

But as the organization matures and grows and starts to build a professional staff, the board members are no longer required to perform these functions. This does not release them from all responsibilities, however. Maturing organizations need board members who can take on additional resource development tasks. The members must be able to bring to the organization financial and other resources, either their own or those of their friends and associates. For a mature organization, the board members must be true partners with the professional staff in the resource development effort. The culture of the board must change, as well; while the original board often "lives" in the organization, the mature board must live in the community.

Unfortunately, many of the board members who were helpful when the company was founded may not be able to give or develop resources; different skill sets are required. But too many organizations do not explicitly recognize the need for change, and the members of the board not able to make the transition are allowed to stay on indefinitely. (Of course, some or all of the senior board members may be able and willing to be very generous and helpful with fundraising as the organization matures.) As a result, the board includes members who can give or get resources — and those who cannot. As new board members with resource generation capabilities are added, a schism develops between factions of the board. The "old guard" feels its past contributions of time and energy are no longer appreciated; it mourns the "old culture" and comes to believe that the organization now cares more about money than art. The "new guard"

feels that those who cannot provide resources are holding back the organization and understands that the role of the board is to generate funds, rather than to provide moral support for the artists.

The board, like the organization itself, is a living, developing organism that must change and adapt over time. Boards that do not mature in a comfortable, stable way will restrict the growth and development of the organization. Over time, the members of the board who could give substantial sums become hesitant to do so, since a portion of the board gives nothing. The board members who do not have the capacity to give or raise funds feel a constant need to justify their involvement with the organization. Obviously, this does not lead to the well-functioning organization of one's dreams.

While the passion and numerous contributions of the older members must be recognized, the organization has a mission, and the board must be composed of those who can help achieve this mission. Being a board member is not an honorary position to celebrate past accomplishments. The board must evaluate itself and decide if the current membership is optimal for the place of the organization on the life cycle. This is an activity that should be pursued regularly, ideally by the governance committee (or nominating committee). If not, there must be a strategy for restructuring the board.

Board and Mission

4 **WHY DO WE NEED A MISSION STATEMENT?**
WHAT CONSTITUTES A GOOD MISSION STATEMENT?

A mission statement is the central management tool of any not-for-profit organization. The mission directs every action of the organization; it motivates the strategic plan; and it explains how the organization will measure success. It is easy to write the mission statement of a for-profit corporation: the mission lies in the words *for profit*. No matter what a corporation puts in its annual report or on its web page, every for-profit corporation has the same mission: to earn as much as possible for as long as possible, so that the stock price is maximized. Measuring success, therefore, is also easy.

In the not-for-profit arts world, developing a mission and evaluating success are far harder to accomplish. All we know is what we are *not for*. But what are we *for*? The rationale for the existence of not-for-profit organizations is that they pursue goals that are not evaluated on the basis of financial return. Society is meant to benefit from these activities that are not financially motivated. That is why a tax deduction is offered to those who contribute to these organizations.

Without a clear and memorable mission, however, arts organizations often secretly, or not so secretly, measure success by their financial results, reverting to the for-profit model, rather than by the organization's achievement of its true artistic and educational goals. Why? Because board members, who typically come from the for-profit world, are far more comfortable measuring success in this manner. (In fact, some board members of arts organizations do not really believe there is a difference between for-profit and not-for-profit ventures, apart from an assumed lack of professionalism and realism among not-for-profit arts executives.) Many arts managers are also prone to measure success in financial terms. They are understandably fearful of the consequences of poor financial performance and are anxious to ensure fiscal stability. But while fiscal sta-

bility is a requirement for pursuing the mission of a not-for-profit, it is not the measure of success. This quandary creates tension in arts organizations and in all not-for-profit organizations.

Those who work for a not-for-profit organization often do so because they get to select the goals of their organizations. They forego the financial rewards of corporate life to pursue their own life goals. So when a board acts as if the mission of the organization is really to achieve financial success, the staff can feel betrayed. They have sacrificed in order to work in a mission-driven organization, but the board does not seem to appreciate the mission.

Lack of universal acceptance of the true mission creates other major problems. It motivates the organization to make poor resource allocation decisions. It encourages programming that sells well, rather than programming that achieves the organization's aesthetic goals. It diverts resources from the most important projects to the most profitable projects, and it encourages less programming, rather than more.

A not-for-profit arts organization that does not work actively to pursue its true mission has not earned the tax-exempt status offered by the state. And an organization that does not pursue its mission is virtually always going to suffer from rifts between the board and the staff, and between the artistic staff and the administrative staff. No matter how the board behaves, the artistic staff will always measure success by the organization's artistic accomplishment, not by financial success.

The real mission is ignored in favor of financial results, when the true mission is not believable or is too vague to be directive. Too many arts organizations have missions that are too general and too philosophical. Mission statements like, "We want to bring the beauty of dance to the world," are not specific enough to direct action or provide measurable goals. When a mission is unclear or unbelievable, most organizations revert to the profit motive, and the actual mission of the organization is lost.

A good mission statement discusses *who* we are trying to serve, *what* we are trying to offer them, and *where* we hope to offer our services. These can change over time. It is not uncommon for an arts organization to rewrite its mission when it expands its services, or when it realizes it has overextended and needs to focus on only part of its mission. But this should be a rare occurrence. An organization that changes its mission every year cannot pursue a focused strategy.

How we are going to offer our programs should not be included in

the mission statement; the way we deliver services is likely to change as the world changes and especially as technology changes. For example, education programs were traditionally offered in person, either at the organization's venue or in the school. Now, a great deal of educational programming can be offered over the internet. It is less important how this programming is offered than what the results are.

A good mission statement can be characterized by four adjectives:

- *Clear*: If the mission statement is not clear, it will not be pursued unilaterally by the organization. The wording must be direct and easy to understand. The use of philosophical language or specialty language cannot be accepted if one wants broad appreciation of the mission among lay people, who may not understand obtuse wording.

- *Concise*: A mission statement must be short enough that people can remember it. I have consulted with an organization with a nineteen-page mission statement! This means that no one can possibly remember it, and therefore, no one will be able to pursue it.

- *Complete*: A strong mission statement describes the boundaries of all that the organization wants to accomplish. If a project falls outside the boundaries of the mission, it should not be pursued, or the mission must be changed. I have observed many organizations that suffer from "mission drift," because they are constantly adding programs that fall outside the boundaries of their mission statements. These organizations are often pressured early on by funding agencies to add these projects. Over time, these extraneous projects become accepted parts of the institution. Eventually, after a series of these projects have been added, no one can explain the real mission.

- *Coherent*: A strong mission statement must make sense. If an organization says it will be the largest theater in its region but will only produce absurdist plays, this does not make sense. The largest theaters in any city tend to produce mainstream plays and musicals. When there are internal contradictions in the mission statement, the mission will not be believable and will therefore be ignored.

If the mission is clear, concise, complete, and coherent, then it has a good chance of being memorable and utilized by board and staff, all of whom will find it rewarding to be part of a unified effort. But arts organi-

zations that have poorly framed mission statements and do not fully embrace their missions — and many do not — are headed for trouble.

5 HOW SHOULD WE DEVELOP A MISSION STATEMENT?

Because the mission statement motivates every major activity of the organization, taking care to craft the statement is essential. Many stakeholders have a right to an opinion about the elements of the statement: board, staff, artists, and volunteers. But it is impractical to bring fifty or a hundred people into a room and ask them to write a mission statement.

A planning committee should craft a statement and then bring it to a special meeting of the board for discussion, amendment, and approval. The board chair, artistic director, executive director, and other key board and staff members should be on this committee. It is ultimately the board that must approve the mission statement, but the entire organization must embrace the mission if it is to be pursued with vigor.

Therefore, before the planning committee writes the draft, it should consult with each group of stakeholders. Rather than solicit complete mission statements, the committee members should ask for elements of the mission: what does each interested party think must be included in this statement of aspirations?

The committee must then meet and sort through the many elements that have been proposed. (Of course, committee members will have mission elements of their own to propose.) There is a simple but crucial test each of the proposed elements must pass, in order to find its way successfully into the mission statement: would the organization be satisfied if it accomplished everything else on the list *except* this element? If the answer is "yes," then the element does *not* belong in the mission. On the other hand, if the answer is "no," — the organization could not be satisfied without accomplishing this element — it *does* belong in the mission statement.

This testing process ensures there is a deep commitment to every item in the mission statement; no one element is more important than the others. By placing these elements in the mission statement, the board is acknowledging that success will be measured by the eventual accomplishment of each and every item.

Once the vital elements have been determined, one member of the committee should attempt to draft a statement for review by other committee members and ultimately by the full board.

What is essential in all of these discussions is that the committee and the full board *not* massage the statement to make it palatable to all members. It is not a problem if the mission statement is so clear that some people on either the staff or the board are unhappy. In fact, it would actually be better for some people to leave the organization after the mission is completed if they cannot accept it, than to have a bland mission statement that appeases everyone but gives no real direction to the organization.

A mission statement needs to be clear, specific, and directive. The more general it is, the more leeway it gives the staff and board to pursue divergent paths. And yet, many boards approve generic statements that could apply to virtually any organization in town. If organizations were willing to develop specific, clear missions, there would be far less tension between board and staff, especially during periods of financial challenge or economic decline.

6 DO OUR BOARD MEETINGS REFLECT OUR MISSION?

Most board meetings of arts organizations seem similar to board meetings of for-profit corporations, since the focus is almost entirely on money, cash flow, interim results, and budgets. While a small amount of time may be spent on the artistic and educational programming of the organization, many of the board members, especially the business people, do not pay close attention to these discussions.

It is understandable for board members to be concerned about their fiduciary responsibility, and to want to avoid embarrassment over financial problems, but it is no wonder that so many board members forget the true mission of the organization. We train the board by the way we structure our board meetings, to believe that we are really a for-profit, financially driven organization. Since for many members these meetings are their major points of intersection with the organization, they judge what is important to the organization by the topics raised at board meetings.

Ironically, when board meetings focus on numbers, many members feel disenfranchised: there is typically a set of board members who only

care about the artistic decisions and whose eyes glaze over during financial discussions. Just as students who are bored or unable to keep up let their minds wander in class, artistically inclined board members start daydreaming when the financially savvy board members take over the meeting. When we "lose" board members over extended discussions about finance, we are also in danger of losing their support. Many members will not be as generous if they do not enjoy their participation, and they certainly will not invite their friends to serve on the board if they feel the meetings are boring or contentious.

Often, board meetings erupt into arguments over how to spend money or whether to spend money. The two factions—the financial wizards and the artists—often find themselves at odds during these discussions. These rancorous disagreements can often discourage board members from coming to meetings altogether.

Board meetings should focus more on the artistic and educational activities of the organization and plans for future projects: in other words, on the mission of the institution and what it is trying to accomplish. At the Kennedy Center, we have a performance at every board meeting. In the middle of the meeting, a pianist, dancer, or children's ensemble comes into the room and performs for the board. Most frequently, these "performances" are related to major projects we are currently producing. This makes it immediately clear why we are there in the first place.

Also at every meeting, we focus on one or more planned artistic or educational programs that we believe are special and that we hope will engage our board. A discussion by a member of the artistic staff, or a slide show on a future exhibition or festival, goes a long way toward explaining what we are trying to accomplish. This also allows staff members the opportunity to showcase their knowledge and professionalism. Since it is critically important for the board to appreciate and trust the knowledge of the staff (and not just the staff leader), these presentations serve multiple functions.

Having board members actively participate in the meetings is also essential. This can be accomplished by asking board members to report on the projects of most interest to them. Each meeting should also include a topic that encourages discussion and sharing of ideas. Too many arts board meetings are simply a series of presentations, with no opportunity for discourse. The chairperson plays a vital role in engaging every board member. Some board chairs enjoy hearing themselves speak (or are

concerned that dissenting views will be expressed on key issues) and do not encourage members to participate. Other chairs do not know how to "referee" a discussion and keep one person from dominating the proceedings. The best chairs make everyone feel welcome to participate, while still ensuring an orderly and productive meeting.

Most board members seem to have a silent clock that sets a specific amount of time they will spend on the organization. They have a sense of when they are spending a disproportionate amount of time on a certain board. It is better to have board members spend their limited time in the community looking for resources and serving as ambassadors for the organization than spending time in endless meetings.

For this reason, it is preferable to have only five board meetings a year, one every other month, except for the summer. The executive committee, acting in place of the board, can also meet five times a year in the alternate months (except summer). Another reason for limiting the number of meetings is that it takes staff substantial time to prepare. If the board meets too often, the staff is spending too much time preparing for meetings and not enough time doing their real, strategic work.

Of course, the number of meetings depends on the situation facing the organization. If there is a crisis, for example, more frequent meetings are required. But even in a crisis, one wants people out doing substantive work, rather than meeting to discuss it. When the Royal Opera House was facing a thirty-million-dollar deficit, the board met weekly for several hours. This essentially meant one day a week was spent on meetings, which reduced the time staff and board had to fix the problem.

Board Governance

7 WHAT ARE THE MAJOR RESPONSIBILITIES OF THE BOARD?

Every not-for-profit arts board in the United States has five key responsibilities that it is obligated to fulfill. The success of the organization, in large measure, depends on the vigor with which the board addresses these tasks. These responsibilities include approving the plan; approving the annual budget; hiring, firing, and compensating direct reports; developing resources; and serving as ambassadors for the organization in the community.

APPROVING THE PLAN

The board is responsible for approving the strategic plan of the organization, including the development of the mission statement that motivates the plan. This is a central responsibility of the board, but it is all too often viewed as a chore.

This should not be simply a once-every-three-years plan development exercise, but an ongoing review of the direction of the organization, to make sure that the artistic, educational, marketing, fundraising, human resources, facilities, security, and IT plans all work to achieve the organization's mission. A board that takes the time to understand the changing environment and the strengths and weaknesses of the organization, and to evaluate all plans based on this analysis, is more likely to chart a smooth course.

Once the board approves a plan, it too often feels absolved of any planning duties until the plan is revised three years later. Nothing could be further from the truth. A strategic plan is a description of the proposed path at a single point in time. As the environment changes, and as the organization succeeds or fails, the plan must be adapted. In fact, the best planners are those who understand the logic flow of the planning process; as something important changes, either in the environment or within the

organization itself, they immediately shift course. It is these entrepreneurial managers who consistently show the very best results, both artistically and financially.

APPROVING THE ANNUAL BUDGET

The annual budget process should be an outgrowth of the planning process. In fact, if the annual budget is not the same as the strategic plan's financial forecast for that year, something is wrong. How can one accept that the strategic plan for the organization results in one set of financial statements, and the operational plan results in a different set of numbers? Yet this dichotomy exists for many arts organizations, and that cannot build confidence in those with access to both projections. Too many boards abdicate when it comes to a solid review of the budget. If the numbers "look in line," and if the entire expense budget increases only a few percentage points each year, the budget is approved without much evaluation.

An accountant, who was one of our board members at Alvin Ailey American Dance Theater, delved more deeply into our budget than most of our board members. But every year, he only questioned our use of office supplies; every other item in the budget was accepted without comment. Why? Probably because this dedicated board member, like members on so many other boards, simply did not understand enough about the expenses and the various sources of revenue of an arts organization to comment with confidence. We must train board members to understand our economics, so that they can fulfill this crucial obligation.

Many board members also approve the budget without any evaluation, because they assume that other members will see to this task. This is a dereliction of duty. All board members have accepted the responsibility of fiduciary oversight of the organization when they joined the board. Regardless of whether they understand financial statements or serve on the finance committee, they cannot ignore this responsibility.

This means that boards must "test" the numbers. Are we doing enough marketing to justify the revenue projections? Do we have a realistic fundraising plan to support the targets in the budget? Do we adequately estimate costs for each production? Do we chronically overestimate revenue or underestimate cost? These and other difficult questions must be asked, first by the finance committee and then by the full board, before the budget is approved. If this rigorous review is not conducted, the board can-

not legitimately complain when a deficit is incurred. On the other hand, this review must be pursued with an understanding of the key factors for sustained success in the arts. Simply cutting artistic and educational programming to achieve a balanced budget is *not* the way to establish long-term stability.

HIRING, FIRING, AND COMPENSATING DIRECT REPORTS

Any arts organization is only as strong as its artistic and executive leadership. Hiring, firing, and compensating these leaders are the third key area of responsibility of every arts board. Most arts boards take this responsibility very seriously, but many do not have adequate knowledge about the skills needed by these key executives.

Too many boards feel that the executive's main job is to control expenses, and they therefore look to hire a financial executive, often from a for-profit corporation. The truth is that financial executives are experts at measuring the fiscal health of an organization, not creating it. What is needed is someone who knows how to work with artistic staff to develop interesting seasons, who knows how to build audiences and donor bases, and who can act entrepreneurially to develop new relationships and resources.

The artistic leader must have a clear vision for the organization, a vision the board and executive staff can support and that is consonant with the organization's mission. The artistic director must also be able to translate this vision into a series of programs that are important, exciting, and affordable.

Poor choices for either of these positions can critically affect the health of the organization. Casting a broad net and using the services of a search firm can be vital, for often the perfect candidate is not readily identifiable from the pool of leaders in the relevant art form.

DEVELOPING RESOURCES

A central responsibility of all not-for-profit arts boards is to help develop resources for the organization. These can be financial resources, human resources, and joint-venture partners. This responsibility is misunderstood by many. The board is *not solely* responsible for fundraising. Frequently the press, the community, the artists, and the staff imply that the board is to blame when fundraising targets are not met. This suggests a misunderstanding about the roles of board and staff.

The staff is primarily responsible for creating a positive fundraising environment, because it is actually the artists and marketers who are the true fundraisers. Without strong programming and an aggressive communications campaign, it is difficult, and often impossible, to attract enough donors to the organization. The staff must also organize and manage the fundraising effort. This is a full-time job (or many full-time jobs) requiring professional expertise. The staff must also manage many of the relationships with donors; since several staff members interact with donors on a regular basis, these staff members become the stewards of these relationships.

But the board must help and must be engaged in finding new board members. Board members must help identify donor prospects and must work with staff to cultivate and solicit donors. Those organizations with boards that do not help with fundraising virtually never succeed over a long period of time.

SERVING AS AMBASSADORS FOR THE ORGANIZATION IN THE COMMUNITY

Arts organizations require the goodwill of a large number of individuals: ticket buyers, donors, press, volunteers, and government officials. Board members are best-positioned to make the case for the value of the organization and its mission to the many members of this pool of potential supporters. This means the board must appreciate the mission, understand the plans, and support the direction of the organization. Unhappy board members, who talk openly in public about the perceived shortcomings of the organization, can do real damage to the organization's ability to build a solid, growing constituency.

The board that actively accepts and fulfills these five responsibilities helps ensure the long-term success of the organization and makes it a joy and privilege for individuals to serve on the board.

8 HOW MANY PEOPLE SHOULD SERVE ON OUR BOARD?

Perhaps the question asked most often by board members relates to the optimal size of a board. The response is that a larger board is preferable to a smaller board. Since two major roles of the board are to help solicit resources and to serve as ambassadors for the organization in

the community, a larger board is more helpful; it has more reach than a smaller board.

The more people on our board, the more likely we are to cultivate individual donors, corporate leaders, foundation executives, and government officials. Staff members are usually not the peers of these influential people, while board members often are. The more board members there are, the more frequently conversations can occur with targeted prospects. When I arrived at the Royal Opera House, the board had only seven individuals, all of whom were passionate about their support of the institution. But they were simply too few in number to reach all of the potential donors we needed to thrive. At the time, the board was appointed by the government; we lobbied hard and won the right to expand the board to accomplish the fundraising we needed.

These facts notwithstanding, it is better to have a potent, involved board of ten members than an unhelpful, uninvolved board of thirty-five. Also, a board should not be so big that staff leadership cannot maintain a personal relationship with each board member.

The most important work of the board does not happen in board meetings; it happens in the community. When individual board members build relationships with potential sponsors and joint-venture partners, they are doing something far more valuable than sitting in a board meeting or a committee meeting.

Though the board leadership is crucial in motivating board members to be helpful in this manner, this work should be managed by staff. So the staff must have the appropriate personnel to provide support to each board member. When a board gets so large that the staff can neither maintain a strong working relationship with each board member, nor follow up properly on leads generated by individual members, the board has gotten too large.

Some symphony boards have as many as eighty to a hundred members. How can a group this large act with a single voice? How can they approve a mission or evaluate a plan? There is no way every member can become the champion of a project when there are that many on the board. And it is hard to imagine that the staff of any organization would have time to build individual relationships with a hundred board members. The board is not a monolithic body, but rather a collection of dedicated people who can be helpful to an arts organization, if they are properly supported and motivated.

Too many arts executives view their boards as a single decision-making body. This does not take advantage of the unique passions, connections, and interests of the *individual* members of the board. If the staff and executive director can build individual relationships with board members, ways can be found to engage them in work that fulfills their individual needs. This strategy usually results in more resources for the organization and much happier board members.

In fact, there is a good rule for arts organizations: staff should have a one-on-one meeting or telephone call with each productive board member every month (except during the summer). This rule does not require strict enforcement, as these conversations happen organically when board members are involved in projects they find exciting and rewarding.

This approach has two major corollary benefits: the board members become much more attached to the mission of the organization because they are excited about programming, rather than balance sheets and income statements — and they also become far more appreciative of the expertise and dedication of the staff, as they engage in projects with them. The result is a more satisfied, motivated board with deep respect for each other's contributions and the work of the staff.

9 WHAT ARE THE BEST LEADERSHIP STRUCTURES? WHAT KIND OF BOARD LEADERSHIP DO WE NEED?

Just as staff needs strong leadership, so too does the board of an arts organization. The board needs someone who can provide direction and set the tone. The board leader defines the way the board members interact with staff, pursue planning, and work to gather resources. And if the triumvirate of board leader, artistic director, and executive director is strong, committed, and collaborative, the organization should be a success.

There are numerous board leadership structures employed by arts organizations, each with differing strengths and weaknesses. They are all variations on four major themes:

- *Board Chair*: The simplest model, which is currently employed by many arts organizations, is a stand-alone chair. This model has the advantage of being the most unambiguous about who has authority.

It also makes clear who the executive director and artistic director report to and collaborate with. But it has the drawback of putting all the responsibility on the shoulders of one individual who must be a manager and a fundraiser, and ideally, a major donor as well. This chair also has sole responsibility for engaging the board members and motivating them to participate. If this single chair has significant weaknesses, or is unavailable for personal or professional reasons, the organization will suffer.

- *Board Chair and President*: Many organizations have both a chair and a board president. This model is perhaps the most popular because it allows for the sharing of authority. In many organizations that adopt this model, the chair is a large donor with fundraising responsibility and other ceremonial functions, while the president is more of an operating leader who works with the board and executive director on major administrative issues. This system has the advantage of allowing two individuals to play different leadership roles and to divide their authority in ways appropriate to their interests and abilities.

- *Co-Chairs*: Some organizations have co-chairs: two individuals who share the duties of board management. This model is typically selected when no one person wants the responsibility of being chair. If the perceived burden of leading the organization is too great, two people, often friends, will agree to share the job. This model can be a bit problematic, since it is not always clear who is responsible for each issue. Also, it can create endless opportunities to play one co-chair against the other, often resulting in serious rifts over controversial issues.

- *Chair and Co-Chair(s)*: This option is not dissimilar from the chair/president model, except there can be multiple co-chairs. This option really places the leadership squarely on the shoulders of the chair, with the co-chairs usually being more honorary positions. In some organizations that adopt this model, the co-chair is in line to become the next chair, and this position is seen as a training ground. In other organizations, the co-chair position is given to someone who has been extremely generous, but who does not aspire to run the organization.

In the end, the success or failure of any of these models rests with the individuals who occupy the positions. All of these models can work with

the right people in the key positions. All of them can fail if the people involved are not strong leaders, are not good collaborators, or do not focus on the mission of the organization.

The selection of a board chair is clearly crucial for an organization. The chair plays a central role in creating the culture of the organization and must occasionally make difficult decisions with the staff leadership. It is essential that the chair and staff leadership present a unified front to the board, staff, and all other constituents.

A strong board leader should know how to run a good meeting that allows for participation by many but domination by none. Board bullies can cause serious problems for an organization. They dissuade less vociferous members from speaking, skew the decisions on major topics, and discourage board members from inviting friends to join the board. The chair must be able to control these bullies from dominating, while at the same time encourage active participation by all board members. Members only feel engaged if they are participating in discussions, events, and projects; board members who are not engaged will not be productive fundraisers or ambassadors for the institution.

The board chair should be able to take advice from staff management but also recognize when things are getting off track. The chair must act decisively when one board member is trying to hijack the organization, when the financial situation is poor and difficult decisions must be made, and when senior staff must be hired, disciplined, rewarded, or removed.

A good board chair embraces the mission of the organization and reminds other board members when it is being ignored. If the chair allows protracted discussions on programs or strategies that violate the mission, it will lose its potency as a strategic tool. When the mission is forgotten, organizational chaos is likely to develop.

A good board chair can also motivate other board members by setting a good example — by giving and getting resources, acknowledging the contributions of each member publicly and privately, coming to events, and showing the importance of board support for the institution's programming. Organizations whose board chair does not do these things well or with true commitment, not surprisingly suffer from a serious lack of resources.

An effective board chair must also motivate staff. This is accomplished by acknowledging staff efforts, appearing at periodic staff events, and demonstrating a sincere willingness to learn from staff. It is rewarding

to staff when a board chair manifests interest in their work; conversely, it is equally dispiriting when the board chair shows no interest in their work at all.

Good chairs should be available when they are needed; they should make the organization a priority in their lives, especially in bad times. When a board chair is absent, the staff leadership must make decisions on their own — decisions that can have a major impact on the health of the organization. If this absence or unavailability continues, other board members try to fill the breach, and the staff suffers from a lack of clarity about the "chain of command." But most importantly, a good chair is someone who can form a team with staff leadership and key board members, and demonstrate support and passion for the organization and its constituents.

Conversely, bad leaders are intransigent and believe they know the right way to run an arts organization — and are going to show others their superiority. They are ungenerous with personal funds and do not help raise funds from other potential sponsors. They do not know how to run a meeting and allow some people to dominate while others sit in the shadows. They are unsupportive to the staff, challenge them publicly, and are not willing to develop a productive working relationship with anyone other than the executive director. They are only available when it is convenient and hard to reach in a crisis. Poor choices for board chair are those who are really there for self-aggrandizement, rather than for the good of the organization.

In the end, a good chairperson provides stability for the organization: constituents know what is expected of them and what behavior is acceptable; staff and board appreciate that they must support the mission and play a role in furthering the mission. Although this stability alone is not sufficient to create success, it does provide a culture in which honest exchange, good decision-making, and personal accountability are far easier to achieve.

IO DO WE NEED BOARD OR STAFF DIVERSITY?

If part of the mission of an arts organization is to serve a diverse audience, it is important to have a board and staff whose members reflect the

diversity of the community. In this sense, the composition of the board and staff reflects the mission. But accomplishing this effectively requires a true commitment to diversity, not simply a sense of obligation or willingness to implement tokenism.

Too often, however, organizations only diversify their boards and staff because they are pressured by funders, especially government agencies and foundations that only wish to support diverse organizations. When an organization changes its behavior just to satisfy a donor or funder, the change is certain to be temporary, superficial, and transparent.

Embracing diversity is important, and when the mission's goal is to serve the many differing elements of society, the organization has to do more than add one minority representative to the board. Putting one African-American or Latino person on the board, for example, is not diversification. Similarly, hiring one Asian-American person to the staff does not represent diversity (unless it is a tiny organization with very few staff members). One can serve diverse communities without their representation on the board or staff, but a true commitment to this mission can be helped by the inclusion of strong leadership from these communities.

Adding diverse representatives can help the organization understand and address the needs of the relevant communities. Minority board or staff members cannot be tokens of our commitment; they are there to provide information, introduce leaders from their communities, build networks, and arrange special projects. Minority members should also help foster relationships between the organization and their communities. Yet it is frequently considered enough to have minority representation on the board and staff. And too often, these minority representatives are told they do not have to make any additional contribution to the institution, that their presence on the board is sufficient. This is insulting to those members. Every board member must make a measurable contribution to the organization.

If an arts institution truly wants to serve a diverse set of people, it also needs to create and present repertory that speaks to each community. For example, it cannot be assumed that the Arab-American community wants to hear Brahms or see a ballet. The organization needs to produce repertory that emerges from their cultures. Over time, we hope all audience members can experience art from both within and outside their own cultures. But the first encounters with arts organizations should feel familiar and comfortable for most audience members.

At the Kennedy Center, we have a Community Advisory Board whose sole purpose is to help attract diverse audience members to the institution. We recognize that our Board of Trustees cannot have expertise in all of the many different communities of Washington, D.C., so we created a group of individuals representing numerous communities in the region. The members of the Community Advisory Board do not provide financial support. They provide information on the repertory that matters to their communities and the best approaches to marketing this programming. They provide access to media, and they help organize outreach activities.

If we are serious about diversity, we also need to make sure that representatives of every community are welcome at all levels of the organization: as donors, audience members, board members, volunteers, and staff. We need to provide training programs to bring more people of color into the arts professions. There is a dearth of trained minority candidates for leadership positions in arts organizations, because this is not a field considered by many parents — in any community — when sending their children to college. Not enough has been done to expose young people, especially those of color, to professions for those with an interest in the arts.

There are many other forms of diversity we must consider, as well, when assessing a board or staff. For example, many organizations strive to achieve gender diversity. If there is a choice, it is best to have the family decision-maker on the board, regardless of gender. When the family "leader" is on the board, the organization is likely to get a far larger contribution.

We also need diversity in terms of the industries represented on the board. When more industries are represented, there is a wider field of potential sponsors, since members of the same business tend to solicit the same potential donors. Also, if the board has too high a concentration of representatives from one industry, the organization is vulnerable if that industry hits hard times, as the financial world did in 2008–2009.

The nominating or governance committee must evaluate the diversity of the board and suggest strategies for change should the balance not be appropriate. Similarly, the executive director and artistic director must work to create diversity in their arenas. But this diversity must be sincerely motivated by the organization's mission, not dictated by any single funding agency, if it is to be potent and effective.

II DO WE NEED BOARD MEMBERS WITH SPECIFIC SKILLS? SHOULD WE HAVE OTHER NOT-FOR-PROFIT EXECUTIVES ON OUR BOARD?

The special skills and knowledge needed on a board depend on the place of the organization on the life cycle and on the skills already resident with the staff. Young organizations, typically with little staff, need board members with the expertise to run the organization. It is very helpful when a small or new organization has board members with accounting and legal skills. The same is true for marketing, fundraising, and other operational skills.

While it is always useful to have financially literate board members, their level of involvement in fiscal issues depends on the expertise of the business staff and executive director. When the chief financial officer has great knowledge, the board provides advice and oversight. When the financial staff has little sophistication, the board must play a more active role: assessing results, producing analyses, and managing cash flow. For those organizations with an endowment or other cash reserves, it is essential to have board members with sufficient investment expertise to manage the funds. Most financial staff members do not have enough expertise to make resource allocation decisions or to select investment vehicles, nor should these decisions be left solely to staff.

Very few organizations are large enough to have in-house counsel. Legal expertise on the board, therefore, can be very effectual, if only to direct the organization to other attorneys when an issue arises and to help solicit *pro bono* legal services.

When the organization is embarking on a special project, like erecting a new building, it is important to bring onto the board a professional who can help guide the project. Rarely does the staff have construction management skills or experience working with architects, engineers, or acousticians. Putting someone on the board with substantial real estate development or construction experience, in anticipation of a building project, can be very beneficial to the organization. But it is essential that this individual appreciate the mission of the organization, the financial situation, and the particular needs of the artists and staff. Building a theater or museum is not the same as building an office tower. It is up to

the nominating committee, in conjunction with the board chair, to make sure that any new member of the board understands the need to collaborate with staff, to ensure that the building project does not undermine the work of the organization.

It is not advisable to place executives of other not-for-profit organizations on an arts board. Many boards bring on local ministers or leaders of other arts organizations, but it is virtually impossible for these not-for-profit managers to raise money for another organization. Even though many people do not like to acknowledge it, not-for-profit organizations do compete with each other for resources. All executives of not-for-profit institutions must devote their fundraising energy toward raising money for the institutions that pay them.

This does not mean, however, that not-for-profit executives should not be asked for advice. Particularly when the organization is dealing with specific issues outside the experience of the board and staff, or when hiring new leadership, selected not-for-profit executives can be very helpful—they do not need to be on the board to give advice. Government officials, on the other hand, can be instrumental if their agencies have the power to be major sponsors of the organization. Politicians or government officials should not be expected to contribute their own resources, but if they have the capability of influencing others to give, this can be very beneficial. Of course, sometimes putting government officials on the board is a requirement when the government agency is a principal sponsor of the organization, or it owns the facility in which the arts organization operates.

Arts organizations of color often have boards that include many not-for-profit leaders, politicians, and church officials. Since these organizations traditionally began life as community efforts, the boards were formed by and of community leaders. Unfortunately, as the organization matures, the board needs to change dramatically from a community board to a fundraising board. This can be a painful transition, and many organizations wait until they are in serious trouble before making the necessary changes.

I2 WHERE DO WE FIND NEW BOARD MEMBERS?
HOW SHOULD NEW MEMBERS BE ADDED?

Once a nominating or governance committee has developed a list of needs for the organization, there is one additional step that must be completed before the committee can begin looking for new board members: there must be a clear delineation of the expectations of new board members. How much must they give? Is there a fundraising requirement? Must they buy gala tickets or tables? Do they have to purchase a subscription? How many board meetings must they attend? Must they sit on a committee? The answers to these questions should be included in a written document provided to all serious prospective board members. All too often, people are asked to join boards and not given a clear understanding of the requirements of board membership. When poorly informed new members do not fulfill all of the expectations, tension can result. The board and staff are disappointed that the new members were not more helpful; the new members feel pressured to do more than they had expected when they joined. This recipe for disaffection makes it essential that everyone asked to serve on a board be informed clearly and early about expectations.

It is similarly important that people of great means and power not be given *lower* expectations for their service. This may seem counterintuitive, but there are numerous examples of wealthy, important people being asked to serve on a board and being told they have to give nothing! The board chairs are eager to attract members of their stature with the hope they will attract other important board members and donors. This rarely is the result. Instead, the other board members who are working hard and giving generously resent that these wealthy and "important" people are doing nothing.

When the list of requirements of service is completed, the nominating committee members, assisted by numerous others, can begin the search for new members.

Where does one look? Everywhere. We talk with everyone we know and discuss what we are looking for. We talk with donors, audience members, and friends. We are hoping to find people who care about our mission, who have resources and access to resources, and who can meet the "give-or-get" requirement set by the board.

We meet with foundation executives and especially with corporate donors. We find that many corporations are happy when their up-and-coming executives are involved with organizations in the community. We try to get local corporations to suggest members of their staff to serve on our board. This may give us access to young executives of high potential who can be supportive now and in the future, as their careers grow — and this almost always results in a corporate contribution. We even approach corporations that have refused to give us a contribution. What better way to build a relationship with an important corporation than to have one of its executives on our board?

We frequently talk with government officials, as well. Although many politicians cannot support us financially, they do have access to people of means. City officials, for example, can be excellent sources for names of potential board members. They know who has resources, who has power, and who has an interest in civic causes.

While the nominating committee may organize the process of finding new board members and do its fair share of solicitations, it is very constructive when others are involved, especially staff leaders. Why? Because it is clearly important that a diverse range of people look for new board members — too often nominating committees are cliques of friends who only look among their own set. This restricts the scope of the search and typically results in board members with the same backgrounds and connections. This approach ultimately limits the fundraising capacity of the organization, since every board member ends up soliciting the same people for contributions and board membership.

Successful not-for-profit organizations consistently bring new groups of people into their "families." So the nominating process must look far afield, for a diversity of people not yet represented on the board. A larger prospecting group makes this much more likely to occur. (This also has implications for who should sit on the nominating committee. The best committees have a mix of people from different backgrounds, communities, and industries.)

But soliciting new board members is difficult if the organization has not done its institutional marketing well — and in advance. When an organization has a strong reputation for excellence, when its events are attractive, and when the community is excited about its work, people are far more likely to want to serve on its board. Before a major board solicitation program can be effective, a strong marketing effort must be in place.

When I was the executive director of the Alvin Ailey Dance Theater Foundation, we needed to replace eighteen board members. We could only do so successfully when our institutional marketing effort was in full swing. After numerous high-profile television appearances and special events, people wanted to be associated with the company.

It is important to note that the Ailey organization was in financial trouble at this time. Despite what many arts board members believe, an arts organization can attract new board members even in times of fiscal instability. If the troubled organization has a strong marketing profile and a smart strategic plan, members of the community will be willing to serve on the board and assist with the turnaround. A strategic plan is the most effective board member solicitation tool. When a plan clearly lays out the goals of the institution, its current status, and the specific path it will take to achieve its goals and create fiscal stability, serious people are more likely to want to join the organization.

Frequently, organizations in trouble need new board members but are afraid that people will not join the board if they see the financial statements. In fact, many try to hide the financial situation before someone agrees to serve on a board. This, of course, is a quick path to a disenchanted new board member. In my experience, people will join a troubled organization if they believe in the plan, if the marketing of the organization stresses its positive impact on society, and if the institution's special events and performances are engaging.

But *how* we add board members will have a lot to do with how effective they are. Too often board members are thrown into their first board meetings without any proper orientation. This means that board members must fend for themselves: they have to determine what is going on, learn how to read the financial statements, figure out the key goals of the organization, and understand the plan for the future.

It is good to give new board members a thorough orientation that explains the major elements of the plan, the financial situation and how it is changing, the major artistic and educational programs, on whom the board members can rely for information, and how they can become involved with the work of the organization. A formal "board book," including all pertinent information about the strategic plan, the staff, and the other board members, can be a very valuable tool.

If a board needs a culture change, as many do, it helps to add new board members in groups of three or four. If a single board member is added to

a troubled organization, that board member will come to meetings, see how other board members behave, and will be socialized very quickly to act like them.

To avoid "poisoning" a potentially strong new board member, assemble a group of new board members, give them a solid orientation, and then keep them separate from the full board for several weeks or months. During this interval they can meet with senior staff, discuss future projects, explore their ideas, and become part of the organization.

After a period of time, when they are introduced to the full board, they will feel at home and will be happy to express their opinions on a range of subjects, including their own ideas for future projects. The senior board members will be impressed by the ideas and knowledge of these new members. They will also be surprised at their optimism. Board members of troubled organizations can get very pessimistic about the future and about the possibility of change. When a group of new members injects optimism into board meetings, it forces the senior members to take stock of their own views of the organization and reassess why they are so pessimistic.

Adding appropriate new board members, and introducing them well, is a central requirement for a healthy arts institution. This takes time, perseverance, and a strong commitment by board and staff. But the positive impact on the institution is immediate, and it creates a new positive spirit at every level of the organization.

I3 SHOULD WE HAVE A "GIVE-OR-GET" POLICY?

Many boards of not-for-profit organizations have a policy that requires every board member to contribute or raise a minimum amount. This "give-or-get" requirement sets the base level of financial involvement for each board member.

Certainly, every board member should do something meaningful for the organization every year. Individuals should not sit on a board simply because they are famous, represent a certain community, or belong to a family that once gave substantial sums of money. While it is exciting to have famous people on a board, just putting a famous name on the letterhead is not enough to help the institution. Tokenism on boards does

not work either. If board members represent a specific community, they must be responsible for helping to engage that community in the work of the organization. They cannot simply sit there at board meetings so that the organization can claim to have a diverse board. And rewarding past donors by placing them or their heirs on a board seriously weakens the ability to raise *new* money. Arts organizations cannot afford to have board members who do not help their institutions in some substantial and measurable way.

The give-or-get policy is one way to ensure participation from all board members. But it implies that every board member should give the same amount and in the same way. In the end, we want the most from each board member, not the minimum. If we are successful in engaging board members in our work, and exciting them about the mission of the organization and our implementation skills, then we are likely to get more than the minimum from many of them.

There are remarkable board members, whose services involve doing the bookkeeping, running a major project, or overseeing the construction of a new facility. This kind of active involvement is real and measurable. Board members who contribute in this manner should not have to give the same amount of money as others. (Frequently, board members of start-up arts organizations contribute only through their service. Since the organization typically has no paid staff, the board members must function as accountants, marketers, and fundraisers; they typically devote huge numbers of unpaid hours to the organization.) Of course, everyone is free to give or get as much as they can; there is no limit. But the base level of financial participation need not be as great for someone who participates in other meaningful ways.

When creating a give-or-get policy, the rules must be very clearly delineated. What counts as a "give"? What counts as a "get"? There are many ways that board members give money to an organization, and the rules must be clear about which count toward the giving requirement. Must it be an outright gift to the annual campaign? Do the tickets purchased for the annual gala count toward this target? Are event tickets or subscriptions purchased counted in this total? When the rules are not clear, the staff is usually placed in the awkward situation of having to explain to the board member what counts and what does not. This is unfair to the staff and can cause friction with the board member involved.

The get policy can also be controversial. Some board members avoid

making any real fundraising effort by taking credit for gifts that others so-licited. It is often not clear who truly deserves the credit for a specific gift. Often it is staff that gets the gift or does the majority of the work servic-ing a donor. Does everyone who might have spoken with a new donor get credit for the gift? And if board members do solicit a gift in one year, does that count against their gift requirement every year thereafter, if the donor continues to give annually?

Since the goal is to maximize the fundraising accomplished by the board, one cannot afford to set rules that result in modest amounts being raised. So it is preferable to have a giving requirement or a give-*and*-get policy, rather than the more traditional give-*or*-get requirement. This forces every board member to make some minimum personal financial contribution or contribution of time and expertise.

How large should the give or get be? That depends on the size of the organization, its funding needs, the capabilities of the board, and the gen-eral giving levels in its home city. The easiest way to determine an ap-propriate give or get level is to survey other similar organizations in your region — similar in terms of budget size, earned versus contributed rev-enue distribution, and reputation. The give-or-get requirements of this sample group will provide an indication of what is appropriate and imple-mentable for your organization.

But this requirement must be modified if your organization has aspira-tions to join the elite group of arts organizations at the highest and most visible strata. In this case, one must evaluate the give-or-get requirements of large, world-class organizations performing nationally, in order to de-termine the level of board support that will be required to reach and sus-tain such status. In general, if the majority of the board is not willing to meet a proposed give-or-get level, then it is either the wrong level or the wrong board. If there are not enough board members in the region to par-ticipate at the recommended level, then the goal is too high, and the am-bitions of the institution must be scaled back — or board members from a more dispersed geography need to be attracted to the organization.

But one should be cautioned against rejecting an ambitious give-or-get because the established base of a board does not want to give or raise that much. That simply means that either the board members have not been excited and engaged enough in the mission of the organization, or that the current board needs to be replaced with a new, energetic, and am-bitious group with greater giving capacity.

The board transformation that was accomplished at Alvin Ailey was essential, because half of the board could not meet even a modest give-or-get level. The board set an ambitious mission that could not be achieved without a larger base of support from the group. We had to find a large number of new board members with greater giving capability. When we completed this task, the organization was set on a path for far greater artistic and educational accomplishment.

14 DO WE NEED TERM LIMITS?

Most not-for-profit boards have term limits. A typical term limit formula might be that an individual board member can serve two terms of three years each, before taking a year off. People who argue for term limits always cite one key merit: term limits allow an unproductive board member to leave the board without anyone's feelings being hurt or having an uncomfortable discussion. When the term is up, the "unwanted" board member disappears, and no one has had to do or say anything. Term limits also allow for a steady flow of new blood onto the board, which keeps the organization from becoming too inbred or stale. As senior members are forced to leave when their terms expire, new members come on the board with fresh ideas, contacts, and resources.

However, there is a very different point of view about term limits for board members. Term limits can be dangerous: they force an organization to lose its best members periodically. These wonderful board members, who are generous, helpful, and supportive, must take a year off the board when their terms expire. They hardly sit at home waiting for the day they can rejoin the board. The best board members are involved, passionate, and committed people, and they will find other objects of their passion. They will join the board of another arts organization or a hospital or a school. You may get them back after a year, or you may not. Their departure for a year or longer can represent a huge loss to the organization.

Term limits, by definition, enforce a serious loss of institutional memory. Since most board members spend a limited amount of time with a given organization, their knowledge accrues over a long period. The knowledge of senior board members, particularly for large, complicated organizations, is a precious resource. It helps immeasurably during tran-

sitions to new staff leadership, when a budget or plan is being reviewed, and when major projects are under consideration. When a board does not have sufficient institutional memory, it cannot provide an adequate check on proposals from the staff. The staff ends up with far too much authority when a board does not have enough knowledge of the organization to be an active part of decision-making.

Many arts organizations have a group of members who have been serving the organization for several decades. These are smart, passionate, generous people who have a strong allegiance to the institution, possess great institutional memory, and have a deep understanding of the mission and plans of the organization. Losing any one of this group would be a great loss; losing them all would be a tragedy.

But what about the need to get unproductive board members to leave? They should simply be asked to leave. One sits down with the problematic board members and suggests that, at this time in the history of the organization, different people who bring different assets are needed on the board. You thank the departing board members for their service, and move on.

Furthermore, it is best to *not* wait even a year or two for a term to end before ridding the board of unhelpful members. Board places are precious; helpful board members are literally worth their weight in gold (or maybe in cash). And unhelpful board members should be removed. But many boards actually reappoint members to a second term even if they are not productive enough, because, once again, they are embarrassed to *not* vote them in for a second term!

However, term limits for board chairs *are* important. On many boards, chairpersons will stay on forever if there is not a simple mechanism that forces them to exit. Chairs should serve for four to six years and then return to the board, while other people take their place. This eliminates the need for an embarrassing palace coup when chairpersons believe they are in office for life, but the remainder of the organization has grown uncomfortable with their leadership.

15 WHAT IS THE FUNCTION OF A GOVERNANCE COMMITTEE OR NOMINATING COMMITTEE?

A well-functioning governance committee, or nominating committee, is central to the health of an arts organization. It is responsible for four key functions related to the healthy governance of the institution:

This committee is responsible for evaluating whether the board, as constituted, is appropriate for the organization. The committee must assess where the organization is on the life cycle curve, determine the nature of the board members needed to move the organization forward, and evaluate whether the current number of board members is sufficient for the task.

The committee must also develop a list of required actions for all board members, in other words, what board members must do to fulfill their responsibilities to the organization. Levels of contributions, attendance at meetings, and other duties must be specified for existing board members, but especially for new board members.

Of course, soliciting new board members is a key function of this committee. But to do this effectively, the committee must also pressure the remainder of the organization to do the institutional marketing and the strategic planning required for successful board solicitation.

Finally, the committee is responsible for evaluating individual board members and determining whether they are fulfilling their obligations to the institution. When board members are not fulfilling these obligations, they should be asked to leave. For those organizations without the heart to do this — but with term limits — the committee recommends which members should not be voted in for another term.

Too many organizations only expect this committee to perform the third role: soliciting new board members. The other three roles are often ignored. This is not the path to a healthy organization. Without performing the first two roles, efficient and effective board solicitation is virtually impossible to achieve on a consistent basis. Many boards completely ignore the fourth key function. But if board members are not evaluated, it is difficult to determine who should be asked for a new term and who should be asked to leave. Any well-managed corporation evaluates its staff; there is no reason that board evaluation should not be similarly pur-

sued for the same reasons. In fact, the governance committee can be considered the board's equivalent of a personnel committee that evaluates senior staff.

Many boards that do evaluate their members employ an annual board member report card. This is a self-evaluation process that allows all board members to evaluate their own participation against each of the required actions for board members. In many cases, it motivates members to do more in the next year; for others, it motivates them to quit the board when they realize they have not fulfilled their obligations in the past and are not likely to do so in the future. The governance committee can then do its own assessment of board members and determine whether they are true assets to the organization.

16 HOW DO WE FIRE UNPRODUCTIVE BOARD MEMBERS?

When the culture of a board must change, when the board is not contributing enough to the institution, or when board members are impeding the work of the organization, the main tool available to an arts organization is to add new board members and ask those who are unhelpful to leave. The question always asked is, "How do you get rid of board members who are not helpful?" The answer is rather simple and direct: ask them to leave the board and make room for others who can be more useful to the organization. Many board and staff members are not prepared to implement this recommendation. They are concerned about the way such a discussion would unfold and fear the consequences. But this need not be a brutal conversation. Most board members who are not pulling their own weight are already aware that they have failed to live up to expectations. They recognize that they are not providing enough time, money or connections to the organization. There are many reasons why this happens:

Some members enter the board with the wrong understanding of their expected performance; they probably were not given enough information at the time they were solicited. For others, the experience of sitting on the board has been disappointing, and they wish to devote their time and energy elsewhere. Most of these board members were not asked to

be involved in the work of the institution. For board members who have served for many years, the organization has simply outgrown them. These individuals should remain involved with the institution, but not as members of the governing body. Other board members are too embarrassed about the organization to want to participate fully. They may be attracted to the mission of the organization but not to the implementation of that mission; they are not comfortable inviting their friends and associates to participate along with them. And still others, who committed to joining the board without fully accepting the responsibilities that go along with board membership, enjoy the perquisites of board membership, but cannot fulfill their duties.

The simple way to ask someone to leave the board is to sit down with the member and say, "You have been a valued part of our board, but at this time in our history, we need members who can produce more than you seem comfortable providing. Would you consider resigning your position in favor of someone who can better meet our current needs?"

This might seem an embarrassing statement to utter, but it is not. It is a simple recounting of facts. If said in a straightforward manner, it does not seem mean or rude. Ideally, it is the chairman or president of the board who is willing to take on this task. If the chairman is not willing to do this, it is the chair of the governance (or nominating) committee who should be pressed into service. And if all else fails, the executive director is the person on the spot.

The most common response to this professional, reasonable, non-pejorative request to resign from the board is, "Thank you." Most people who are not adequately serving an organization are just as unhappy to be on the board as the remainder of the board is to have them. They know they are not meeting requirements, nor being helpful enough. But they are as embarrassed to quit the board as the board is to ask them to leave. They fear their resignation makes a public statement about their lack of interest in the organization. One is doing them a favor to give them a gracious, comfortable way out.

However, it makes sense to keep departing board members involved with the organization as volunteers or donors. We are not *divorcing* them; we are just suggesting that they form a different kind of relationship with the organization at this time.

When an organization has the courage to ask under-performing members to leave, it encourages and energizes everyone else. As the unpro-

ductive members depart, all of the remaining board members take notice. They recognize that they have responsibilities and that they will be held accountable for fulfilling them. They also appreciate that if they are not pulling their weight, they will not be accorded the benefits of board membership. This is a very motivating activity. That is what should be kept in mind when asking someone to leave a board: how it will influence positively the remainder of the board and staff.

It is also important for the staff of an organization to recognize that there are consequences to board members who are not productive, or who make it difficult for the organization to do its work. This reduces substantially the ability of staff and artists to point to an ineffective board as a reason for the organization's problems.

The alternative to asking bad board members to leave is to keep them until they eventually decide to resign. This has the benefit of not creating a potentially embarrassing discussion. But it has a negative impact on every other member of the organization. Good board members are disgusted that the unproductive members get away with not producing; staff members are disgusted that the board is not forced to fulfill its obligations. There is a weight placed on organizations that have one or several unproductive members. Removing that weight might be uncomfortable for a few minutes, but it results in years of better morale and better performance.

At the Alvin Ailey organization, there were thirty-six board members, eighteen of whom were unhelpful for a number of reasons. In asking these eighteen to leave, we made room for a much more valuable group of board members. We energized the remaining board members, and we motivated the staff to work more closely with a more potent board. This set of actions changed the history of the Ailey organization; it allowed the company to build a far more substantial fundraising base, especially from individuals, and it eventually led to the construction of its new home. If we had not changed our board substantially in 1992–1993, the organization would not have attracted and motivated the caliber of board member that it did for the following decade. A few feelings might have been spared, but there is nothing in the Ailey mission about giving unproductive board members a permanent home.

17 APART FROM A GOVERNANCE COMMITTEE, WHAT OTHER COMMITTEES DO WE NEED?

As this book should make clear, there is a great deal that the board must understand and review to be fully effective. It is unlikely that every board member will have the time and expertise to be involved in every aspect of operations. Therefore, strong, credible board committees are vital. Committees make it easier for a board to get everything done without overloading any one board member.

There is no legal number of committees a board should have, but the by-laws of the organization should specify the standing committees. A board of more than fifteen members should have an executive committee. This is the group that acts in place of the board when the board does not meet. The executive committee can also deal with some sensitive matters that perhaps should not be brought before the full board. The executive committee should be composed of the best, most committed board members; typically, the other committee chairs are asked to join this committee.

Every board should have a finance committee that delves into the fiscal results and explains them to the full board. This is the committee that reviews budgets and other financial forecasts, including cash-flow forecasts, so that financially illiterate board members can have trust in the numbers. It is critical that this committee not just rubber stamp the staff's decisions; if it does, it serves little purpose.

Every organization that has an outside audit performed annually must also have an audit committee — separate from the finance committee. This is the committee that engages an auditor and reviews the results with the auditor. This committee is crucial, because it provides a check and balance to the staff and to the finance committee. The members of this committee should not overlap with the members of the finance committee; the audit must be independent of all other activities to help ensure that there is no fraud taking place.

Many boards have development committees that oversee the fundraising effort. This, however, can appear to absolve the board members not on the committee from fundraising. In fact, some of the most potent fundraisers on a board may not be willing to serve on a development commit-

tee. They may be happy to call a few prospects they know, but do not want to take the time to attend committee meetings. It is preferable to define the development committee as the group that *organizes* the board's fund-raising activities, rather than the group responsible for doing the actual fundraising. The solicitation of gifts should be everyone's responsibility.

Those organizations owning their own offices, galleries, or theaters, typically have a building committee that oversees the way these build-ings are maintained and all capital investment projects. This committee reviews plans and budgets for operations, maintenance, and capital proj-ects. It ensures that capital projects are progressing on time and on bud-get. This is especially important for those organizations building new facilities. A real-estate developer or building professional is a good choice for chair of this committee.

Another optional but sometimes problematic committee is a market-ing committee that oversees the communications activities of the organi-zation. Too often, members of these committees are marketing executives with for-profit corporations. Since the marketing of a not-for-profit arts organization is very different from that of a corporation, the expertise of the board members may not be particularly germane. The remainder of the committee is usually composed of board members who believe they have "good marketing ideas." There is real expertise required to formulate a marketing campaign for an arts organization. Corporate marketers and other lay board members must be willing to learn about arts marketing if they want to form a helpful, productive committee.

More controversial, however, are programming committees formed by many visual and performing arts organizations. These committees are charged with reviewing the programs for future seasons and ensuring they are of high quality and can be supported financially. These commit-tees are only useful if they work many seasons in advance. All too often, programming committees review only the upcoming season; by the time the committees meet to discuss the programming, the repertory is already set, contracts are signed, and marketing and fundraising are in progress. There is little the board can do at that point to make changes, which can lead to very frustrated committee members. It is also essential that these committees appreciate their function to oversee, not to develop, pro-gramming. Programs developed by committees are rarely successful and never cohesive.

Committees are crucial to the knowledge of the board and the health

of the organization. Committee chairs must be well chosen, and members must have credibility with the remainder of the board and staff to be fully effective. In general, it is best to minimize the number of committees on which any one board member sits. The most important work is done outside of board meetings and committee meetings, and therefore the number of meetings that any one board member is asked to attend should be kept to a minimum.

18 SHOULD THE ARTISTIC DIRECTOR AND EXECUTIVE DIRECTOR SERVE ON THE BOARD?

Both board members and staff members frequently ask the same question: should the artistic and executive directors sit on the board? There seems to be a great deal of anxiety on both sides of the issue. Many directors believe they should be on the board and that their hard work and knowledge of the issues makes it imperative that they have a vote on critical matters. They are concerned that if they do not sit on the board, they will not be viewed with respect and will not be able to influence key decisions.

Many board members feel the opposite way. They believe there should be a clear separation between board and staff. They also want the board to be able to meet and talk freely without staff being present. They feel it stifles conversation if staff leadership is in the room for certain crucial discussions.

The best answer to this question: it doesn't matter; if the only way the staff has a say on a crucial and controversial issue is through the votes of the executive director and the artistic director, they have lost the vote and the confidence of the board anyway. No important issue should be decided by a single vote. When controversial issues come to the board for a vote, an executive should have discussions with individual board members before the meeting to determine the mood of the board and to lobby for their support. This gives board members who oppose the staff recommendation a chance to vent their feelings; at the very least, it should make board members' comments to the full board less challenging. If there is strong, unmovable sentiment against the staff's proposal, the proposal must be amended or dropped.

If a board cannot have an honest discussion with staff present, then that board does not have the courage and honesty required for an effective governing body. Board members must not be embarrassed to express their feelings openly with the staff. If the institutional culture does not permit this kind of honest interaction, it will be difficult for the organization to pursue an effective planning process or to coalesce into the united front so essential for success.

Of course there are some discussions that should happen without staff present. But staff can be excused from a meeting, even if they have a board seat. What matters are honest, mature, board/staff relations. It should not take a technicality about who has a vote and who does not have a vote to solve a problem. In my experience, whether or not staff sits on boards should not make a difference to the organization's chances of success.

Board and Fundraising

19 ARE WE RELYING TOO HEAVILY ON CONTRIBUTED REVENUE?

Many board members believe that their organizations depend too heavily on contributed revenue. Typically, a substantial percentage of board members on any arts board come from the for-profit sector. Corporate executives often cannot understand why an arts organization cannot balance its budget solely with earned revenue. They believe that if only the organization were run more efficiently, or performed repertory that was of interest to more people, there would be no need for contributions.

Most board members desperately want to reduce dependence on fundraising. They are not comfortable asking their friends for funds and are convinced that selling tickets is a far more controllable, predictable source of revenue than requesting contributions. Therefore, this line of reasoning continues, organizations that earn most of their revenue control their own destiny and are far healthier.

When I arrived at Alvin Ailey in 1991, the company was earning seventy-five percent of its budget. The board felt this was a sign of health, since it meant that the company was not reliant on the vagaries of fundraising. It was actually a sign that the organization was not very good at fundraising. There was far more money to be raised by the Ailey organization: this was one of the most famous dance companies in the world, it regularly performed across the nation and the globe, and it had a very loyal audience base. Yet fundraising efforts were stagnant. If we could increase the level of contributions, we could pay off the deficit and put less pressure on the dancers to perform as often as possible. This would lower our earned-income ratio, of course, but we would be a far healthier organization.

In fact, there is no one *correct* ratio between earned and contributed revenue; it depends on the organization, its constituency, its board, its location, and its mission. But despite the wishes of most board members, contributed revenue is generally becoming increasingly important in the arts world. Arts organizations cannot easily increase earned income, ex-

cept by raising ticket prices. And since there are so many potent and competing electronic substitutes, raising prices is not easily accomplished at this time.

Also, when we continue to raise prices, we disenfranchise large portions of our audience. This may not matter to some board members as they try to balance the budget, but it does violate the mission statements of many organizations. Therefore, over time, as costs rise, a larger portion of revenue must come from contributed funds.

This notion scares board members, because they believe, erroneously, that fundraising depends solely on a large number of personal requests by board members to their friends. In fact, healthy arts organizations attract an increasing number of donors naturally. When the programming and marketing of the organization are strong, more and more people want to become associated with it. The staff must do a good job of making it easy for these new constituents to become donors and of servicing their needs. At the same time, as the institution's reputation grows, the staff has the opportunity to solicit more corporate and foundation gifts and to build the membership effort. Of course, it is important that board members solicit their friends and associates, but this is hardly the only way for a fundraising effort to grow.

20 HOW DO WE ATTRACT CORPORATE CONTRIBUTIONS? FOUNDATION CONTRIBUTIONS? INDIVIDUAL CONTRIBUTIONS?

Since unearned income is crucial to the financial health of the organization, it is critical that board members understand the rudiments of fundraising. There are two basic rules of fundraising: the first is that healthy fundraising is about the development of the relationships with the donors. It is usually not effective to ask people for a large gift on a first meeting; we must allow the prospects to get to know the organization before we ask for a major contribution. And often, the first gift by donors will be of modest proportions. As they become more involved in the work of the organization, the size of the gifts can increase substantially.

The second important fundraising rule is that one must listen to

donors to determine their interests and their giving priorities. Too often, prospective donors are inundated with information about one specific project for which an organization needs funding. But if this project is of little interest to the donors, they might give nothing or only token gifts. It is far more effective to listen to donors and assess their interests. The solicitor can then select from a list of future projects and suggest the ones that best match the giving interests of the donors.

This is a far more effective way to approach fundraising and traditionally results in more gifts and bigger gifts. But *how* we ask, and *what* we ask for, depend on the nature of the donor. That is why it is essential to understand the basic giving motivations of corporations, foundations, and individuals. (I have omitted government fundraising, since it is impossible to generalize about approaches that increase the odds of success with government agencies. In many instances, government agencies work like foundations, accepting applications and making systematic judgments about which organizations should be funded. In other instances, they seem to require more individual solicitations, where personal contacts and personal rewards appear to govern. Each arts organization must discern how government funding "works" in its own jurisdiction and react accordingly.)

The reasons corporations make contributions has shifted considerably over the past fifty years. Half a century ago, corporations were more deeply rooted in their communities. Who could think of Hartford without thinking of the insurance industry or Milwaukee without its breweries? When corporations were locally owned and operated, they typically had a paternalistic attitude toward the not-for-profit organizations in their home towns. As a result, they tended to make contributions to a number of important local arts organizations, which counted on these gifts as if they were an annuity. Some companies, although a shrinking number, still have this relationship with their communities.

But as corporations merged and were purchased, as local relationships began to evaporate, and as shareholders became more global and more demanding, the relationship between corporations and arts organizations changed dramatically. Now corporations must justify their investments in not-for-profit organizations. They must make the case that this involvement is good for the shareholder, who may live thousands of miles away and has no investment in the community.

In most cases, this justification is found in the corporation's market-

ing strategy. As corporations look for ways to attract and keep their customers, they have become aware of the power of selected sponsorships in the arts. We have all been exposed to corporate sponsorships of sporting events. Most of the time, these are highly visible, for-profit sporting events that bring luster to the corporations that sponsor them. In the new corporate giving environment, arts organizations must be able to make the same case. To receive substantial corporate support, an arts organization must be able to demonstrate that it has access to, and influence with, the clientele the corporation is seeking to service.

No longer are corporate gifts annuities; they must be earned periodically by providing high levels of visibility for the corporate sponsor. Therefore, arts organizations that receive corporate support are usually the largest and most visible. They are the ones that know how to create institutional images for themselves and for their sponsors. Of course, the most effective way to demonstrate the institutional marketing skills of an arts organization is to mount a substantial institutional marketing campaign.

It is terribly difficult, therefore, for small arts organizations to receive support from large corporations; they simply don't have the marketing or advertising strength to convince corporations that they would profit from the marketing campaign. But even small arts organizations can develop support from local businesses by providing them with visibility at performances.

Even in-kind support from small businesses can be very helpful to the budget of these smaller organizations. (In-kind support is a gift of merchandise or services rather than cash.) When these gifts reduce the expense budget of the organization, they are as good as cash. For example, a local restaurant providing the food for a budgeted fundraising event is saving the organization from having to spend that amount. This is called "budget relief." When the in-kind merchandise or service does not replace a budget item, it is less helpful to the organization in financial terms.

There are still some corporations that routinely sponsor numerous local groups. But these are the exceptions. When there are personal relationships between board members and corporate leaders, an arts organization might still receive an annual gift, even if it is not tied to visibility. But in this instance, though the corporation may be paying the bill, the CEO of that corporation is acting like an individual donor, rather than a corporate donor.

Arts organizations that are growing and building audiences have an opportunity to start developing a corporate donor base. This requires a strong, individually tailored visibility plan for each corporation the arts organization approaches. It makes no sense to send out hundreds of identical corporate solicitations. When a proposal shows no understanding of the special situation and strategy of the corporation, it will get very little attention. A far more effective approach is to study the strategy of an individual corporation and determine how one's organization can help with the marketing component of that strategy.

The nature of the corporation will have a substantial influence on its needs. Many are looking for "coverage"; they sell their products to so many consumers that their marketing efforts focus on reaching the most number of people, as often as possible. Consumer products, commercial banks, and airlines, for example, all fall in this category. These types of corporations typically seek partnerships with the largest, most visible arts organizations. When an arts organization submits a proposal for sponsorship from one of these corporations, it will be evaluated on the basis of the breadth of its marketing reach. The amount of advertising; the number of households receiving magazines, newsletters, and direct mail; and the number of visitors to the venue are all measures of interest to the corporation. Another is the number of visits to the arts organization's web site. (Since attracting visitors to its own web site is important to the corporation, creating links between those of the organization and the corporation web site is a valued benefit for a corporate sponsor.)

But other corporations with relatively few clients must invest heavily to attract and retain each one of them. For example, investment banks have far fewer customers than a soft-drink distributor. For this reason, every investment bank is willing to spend far more to market to a prospect than will a consumer products company. Arts institutions can easily satisfy the needs of these companies: they are in the business of creating magical experiences and producing remarkable events that can make any client feel special.

At American Ballet Theatre, for instance, we developed a glamorous night for the corporate donor. In exchange for sponsoring an evening's performance during the company's Metropolitan Opera season, the corporation was given a specified number of the best box seats for its important clients. After the show, all of the guests were brought backstage

for champagne with the principal dancers; they received programs auto-
graphed by the dancers, signed toe shoes of the ballerina, pictures with
the cast, and more. This plan took advantage of the best ABT had to offer
— and the clients were always deeply impressed.

In some ways foundations are the easiest donors to solicit, and in other
ways they are the most frustrating. They are easy to work with because
they have an obligation to give away at least a certain percentage of their
endowments each year. We are not taking money they otherwise could
spend on themselves. We do not need to convince them to give; they are
obligated to give. (This refers to professionally managed foundations, not
family foundations that often act more like individual donors, or corpo-
rate foundations that tend to act like corporate donors.)

But foundations can also be frustrating, because the reasons they sup-
port some projects and not others can be arbitrary and hard to decipher.
A foundation may support arts education one year and pull that support
the next year. It is also hard to know who the decision-maker is at a given
foundation. Therefore, we are not sure whom to lobby to ensure that our
proposal is received positively.

The key then to getting funding from a foundation is to work hard to
determine what kinds of proposals it is supporting at this time and with
whom to meet to discuss the request. The fact that a large foundation has
a lot to give does not necessarily mean it will come your way.

Because a foundation grant application can take substantial time to
prepare, one does not want to apply if the project has little or no chance
of being funded. It is worth the time to research what the foundation says
it supports and to study past grantees, award amounts, and purposes. This
will give a good indication if your organization is a reasonable prospect
for that foundation or not.

It makes no sense wasting a lot of time approaching foundations if a
project is not likely to be of interest. It looks unprofessional to approach
a foundation that only supports contemporary music, with a museum
exhibition proposal, for example. In fact, the most constructive thing to
say to a foundation executive after realizing your slate of future projects
doesn't fit its giving criteria is, "I'm afraid I don't currently have a project
that would interest you." This shows you have been listening and estab-
lishes your maturity and professionalism. In the future, when you do have
a project that fits the guidelines of that foundation, you will certainly get
serious consideration.

The proposal to a foundation must be clear, professional, and accurate. Foundations are not unlike colleges, evaluating applications. The proposal has far less emotion than an individual donor request and less of a sales-job aspect than a corporate solicitation. A foundation application is typically read in an objective, dispassionate way. It rises and falls on its own merits. It must be well written, compelling, carefully researched, and most importantly, believable.

All this is not to say that it is unhelpful to have friends in high places in a foundation. If a member of the board or staff has a good relationship with an executive or especially a board member of a foundation, it makes it easier to get a good hearing. And meetings with foundation executives can be extremely useful in preparing a solid application and having another opportunity to explain your project to a sympathetic ear. So the names of senior staff and board members of the foundations being solicited should be routinely passed along to all board members for their review. This should be one of the tasks of the board development committee.

Finally, every board must appreciate that foundations rarely support an organization *ad infinitum*. Unlike individual donors who can write checks every year for a long time, foundations are far more likely to change the focus of their giving — to avoid having organizations count on their support for survival, and to spread their gifts to more institutions.

Therefore, if one receives a large foundation grant, especially one that increases the size of the organization substantially or takes the organization into a new program area, the board and staff must plan, from day one of the grant, how they are going to replace the foundation funds when the grant period is over. Too many organizations, so happy to receive significant funding, feel they can relax during the grant period, rather than use the gift to motivate other giving opportunities. As a result, the world is littered with arts organizations that "got sick" when a grant was concluded, the expenses of the program were no longer covered by the foundation, and no steps were taken to find donors to replace the grant funds.

Individual donors are the most loyal and most plenteous of donors. And unlike corporate and foundation donors, they tend to give even when the economy is faltering. Not surprisingly, individual donors are the bedrock of fundraising efforts and give more than sixty percent of the funds donated to the arts each year in the United States.

One must separate individual donors into two main groups: members

and major donors. Members are lower-level donors who care deeply for the work of the organization and receive modest benefits for their gifts. Most members cherish experiences: dress rehearsals, early purchase opportunities for tickets, lectures, and other special events. Some arts organizations attempt to reward members with merchandise, most frequently t-shirts, mugs, umbrellas, key chains, and lapel pins. While these items are appreciated, they are usually expensive to manufacture and deliver. It is crucial that the arts organization not spend more on each member than it receives; the costs of delivering benefits and communicating with each member must be carefully evaluated.

Membership efforts work best when the art is exciting, visibility is strong, and memberships are marketed consistently and aggressively. Placing an advertisement in the program book is generally not sufficient. Announcements at performances, a membership table in the lobby, and online and direct mail solicitations are required. To build a membership program, one must work to develop an initial group of members, and then give incentives to these members to involve their friends. In this way, membership groups can grow exponentially, and the rewards to the arts organization from having a committed group of donors can be great.

Efforts should be made to increase the annual gift of each member by offering increased benefits and recognition for a larger gift. Over time, some members will grow to become major givers. Major givers are those who donate in amounts that are meaningful to the organization. For small organizations, this might mean a gift of $500 or $1,000; for very large organizations, this might mean a gift of $25,000 or $50,000.

Members give so little that inexpensive, mass-communication techniques must be employed to stay in touch and renew their gifts; major donors give enough that they can be serviced individually, and the benefits offered to them can be tailored to meet their specific needs.

Major donors typically give for one of four reasons: some truly love the artistic and educational programming of the organization. These are the most valued donors because the organization simply has to pursue its mission to please them. These are also the most faithful donors, because they get so much satisfaction from the programming itself, they tend to care less about the perquisites than other major donors.

Other donors enjoy meeting celebrities and spending time with them. They value smaller, more intimate gatherings where they can talk with and get to know the star performers. This is not a difficult challenge for those

arts organizations that routinely work with major stars. For other organizations, it is a motivation to involve celebrities in their special events.

Many major donors enjoy the prestige attached to being involved with an arts organization of stature. These donors respond to a strong institutional marketing effort: the more visible the organization, the more attractive it is to this segment of donors. Of course, most of these donors want their names associated publicly with the organization; finding appropriate ways to create this visibility is essential to maintaining gifts from these individuals.

And some major donors give to arts organizations because they are looking to take part in a social life; smart arts organizations know how to create a welcoming environment and a series of important events to entice these donors. Most of these donors simply enjoy participating in events that bring them in periodic contact with their friends and acquaintances. A smaller set seeks even more frequent involvement with the organization to enrich their lives.

But regardless of the nature of the donors or their giving motivation, arts organizations that build strong, mutually beneficial relationships with their donors — listening and responding to their needs and involving them in their work — are going to be successful at building a strong fundraising base of support.

21 HOW DO WE MAXIMIZE THE RESULTS OF OUR ANNUAL GALA?

The annual gala has the power to be a major source of funds, a magnet for potential donors, and a force in creating an institution's identity in the giving community. But too few arts organizations take full advantage of their annual galas.

A gala can only be successful when the board is active enough, and the donor group potent enough, to result in strong ticket sales for the event. The event must be attractive, engaging, and fun; it must have elements that make people want to come — and to come back the following year. But the organization must be careful about its expense budget for the event. Many arts organizations spend so much on an event that they net very little profit after a great deal of effort. This is particularly prob-

lematic because many attendees believe they have made their annual gift to the organization by purchasing tickets or tables. The fact that their purchase resulted in little or no net profit for the organization is unclear to the ticket buyers.

Since there are likely to be many people at the event who have not had opportunities to view work presented by the sponsoring organization, galas should feature that work whenever possible. Even award dinners, or dinners that honor someone of note, are enhanced when there is a performer or performance with a clear relationship to the organization. Every fundraising event should feature a performance or exhibition; this is the organization's time to shine and to convince people that its mission is one that deserves support.

When one or more celebrities are added to the gala, it becomes so much more appealing and special. People will remember an event if they meet someone they admire. Ask a celebrity to serve as a host; if you can involve an important artist related to your genre, so much the better. For those potential major donors who like to meet stars, this can be particularly enticing.

A great deal of time is spent planning the logistics of the gala. For many organizations, more time should be spent before the event, planning a donor cultivation strategy that will ensure maximum pay-off. Every board member should be assigned to meet and greet several prospects who are coming to the event. The board members should be responsible for talking to their prospects, making them feel welcome, and helping them understand the work of the organization.

Follow-up is essential to realizing the full potential of a gala. Every guest should be thanked after the event and invited for a private meeting or tour. If a systematic, disciplined approach to follow-up is employed for every guest, a gala can result in a greatly expanded prospect list.

It is critical, therefore, that every element of the event be perfect—and planned. Organizations with truly professional event planning create galas that people want to come back to. If the "return rate" is high, then the organization can build on its gala success from year to year. This is particularly true if the guests of "table buyers" enjoy the event. Galas are funnels: they bring to the organization new prospects, friends, and associates of the board, and other donors. When someone buys a table, there are eight new people to solicit in the future. Many of these may buy tickets or tables of their own for the next year's event. If the demand for

tickets continues to rise, ticket and table prices for the event can be increased over time, as well. As with all fundraising, a disciplined approach over a number of years helps to build the fundraising revenue.

When successful, these events are also vital because they become a highlight in the participants' social life. Since for a group of major donors, enhancing social life is a key reason for supporting an arts organization, this is of no small import.

A large organization can have several fundraising events a year. A smaller organization might only have one large fundraiser but can add several other events over the year — special performances, private dinners, lectures, or receptions — that make patrons feel that their social life is intertwined with the organization. When that belief prevails, the donor base is certain to grow.

22 HOW DO WE EVALUATE A FUNDRAISING PLAN?

Board members have two key responsibilities with respect to fundraising: they must help solicit funds from their friends and associates, and they must evaluate the fundraising plan. While many organizations may not have a written fundraising plan, such a plan is implicit in the annual budget projections for contributed income.

Virtually every arts budget includes projections for fundraising revenue from each major category of donor. Too many boards approve these projections if they "look reasonable," without delving any deeper into the numbers. It should not be surprising, therefore, when fundraising revenue falls short of the target.

Before the board approves the budget, it must understand the thinking behind the fundraising revenue projections. Are they simply plugged-in numbers, calculated to balance the budget? Are they realistically based on the artistic programming and marketing campaigns planned for the year ahead? Do they differ radically from previous results? Is there a change in the environment or economy that will affect fundraising revenue in the coming year? Without asking these questions, the board is in danger of approving a budget that "looks reasonable," but is not.

Simple analyses can help reduce the risk of approving an unrealistic plan. Calculate the difference between *projected* fundraising in each cat-

egory and *actual* revenue the year before. Question the development staff and the executive director about the steps being taken to achieve the increase. (Projections virtually always show an increase unless the organization had an extraordinary gift or project the year before, or the economy is moving into a deep recession.) If the answer is simply that the staff will work harder, this is not sufficient to warrant an increased projection in revenue. Wasn't the staff working hard last year?

Ask about any large or extraordinary gifts included in the forecast. Are these gifts already pledged, or are they just vague hopes at this time? If the gifts are not pledged, assess the percent likelihood of each gift, and multiply each gift by this percent to get a more realistic projection. (For example, if one believes there is a 60 percent chance of receiving a gift of $10,000, one should budget for 0.60 x $10,000; that is, $6,000.)

Ask what the organization is doing to create visibility for its corporate donors. Have benefits been created that are tailored to the needs of the individual corporate prospect? If the answer is not satisfactory, it is unlikely that a growing corporate revenue target will be achieved.

Ask about the specific projects being proposed to each foundation to ensure that a realistic foundation budget has been developed. Do these projects meet the giving guidelines of the foundations being solicited? The foundation line in the budget is likely to change more dramatically than others from year to year. Some foundations will stop funding, while others may give a major new grant. A foundation line that moves in lockstep with other budget lines has probably not been thought through carefully.

Evaluate the projected growth in membership. How does this compare with growth in previous years? Membership is one category that does not tend to grow more quickly from one year to another, unless a special event or promotion increases enrollment significantly. For example, some presenters see a big growth in membership in a year when a highly popular musical is presented; many audience members are concerned they will not have access to good seats unless they enroll as members. Unfortunately, the year after the presentation, membership rolls may decline if another popular attraction is not presented.

Is the revenue growth forecast for your major individual donors consistent with your programming and marketing plans? The increase in major gifts is typically motivated by special artistic or educational programming planned for the season. In addition, new major donors will emerge when the organization has been producing important programming for sev-

eral years in a row; the cultivation process can take several years for certain donors. If the organization has been consistently producing exciting work, marketing aggressively, and fostering potential major donors, it is not unrealistic to expect this income to grow.

Are you projecting growth in government grants? What indication do you have that government funding will increase? Any board must remain skeptical that government funding will increase dramatically in any given year, unless there has been a serious lobbying effort and an indication from government officials that such an increase is realistic — it virtually never happens spontaneously.

Are special-event revenue projections in line with your expectations? If you are anticipating increased revenue, have you also increased costs to account for more guests? Have the past several events been a success? Did they lay the groundwork for a more profitable event this year? Is it time to raise ticket prices?

In short, there must be a strategy in place for every increase. There is nothing that automatically guarantees increases in fundraising revenue every year. Increases must be earned.

The effect of the economy must be evaluated, as well. Anyone doing a budget for the 2008-2009 fiscal year must have acknowledged that the recession was going to reduce grants from almost every source. If a board simply approved a three or four percent increase for that year, the organization would almost certainly sustain a major deficit.

Finally, the board must evaluate whether the organization has adequate staff size and strength, and sufficient board involvement, to achieve the proposed budget. If a large increase in major donors is anticipated, for example, then the budget for staff time to service these new donors must also be increased. If is not, then either the budget must be changed or resources must be added.

23 ARE BOARD MEMBERS RESPONSIBLE FOR FUNDRAISING? HOW DO WE GET BOARD MEMBERS TO RAISE MONEY?

Virtually every article published about a troubled arts organization includes variations on the same sentence: the organization failed, in part,

because the board did not discharge its obligation to fundraise success-fully. This is a naïve point of view. Boards are not *responsible* for fundrais-ing. Board members must be a part of the fundraising strategy, but staff leadership is ultimately responsible for making sure the fundraising effort is robust. Staff must also work diligently to market to board members; this means that staff must make an effort to excite board members about the work of the organization, so that they *want* to ask the people they know to provide support.

This is a controversial point of view. Many arts leaders believe that the board must help raise funds, whether or not they are motivated and ex-cited. This is perhaps a strong moral position, but not an especially practi-cal one. If board members are not certain that their friends and associates will have positive experiences with the institution, and if a staff profes-sional does not help board members who are usually inexperienced solic-itors, then the board will probably not raise what is needed.

In fact, most board members do not know how to fundraise and are uncomfortable calling up friends and asking for money. So when the tra-ditional call is issued at board meetings that "everyone has to help with fundraising," this falls on deaf ears.

There are two simple ways to get board members involved in fundrais-ing: the first is to create a fundraising program that is easy to explain and that solicits gifts at a reasonable level. Many board members who are un-comfortable asking for money are happy to ask friends to purchase tick-ets for a gala. Why? Because the *quid pro quo* is simple to explain: the friends buy tickets or a table, and in return they get a special evening with wonderful entertainment and a fine meal with friends and others from their social set. It is far harder for many board members to explain to their friends all the programs of an organization, its mission, and why it de-serves support.

One successful tactic is to create a package that looks like a gala invi-tation, but is really a request for operating funding. The key is to select a gift amount that is comfortable for board members to request from their friends.

When I was at Alvin Ailey, the board was comfortable asking for $1,000 from friends and associates. So we created the Ailey Partners pro-gram, which was sold just as a gala is sold, through an invitation. There were benefits for giving the $1,000. The primary benefit was that every Ailey Partner would be listed in a full-page advertisement to be placed in

The New York Times after we had successfully attracted a hundred Partners. This program generated $160,000 very quickly, doubling our annual fundraising from individual donors.

Ailey Partners also made the board members very proud and excited that they could be effective fundraisers, even though all they had to do was send a few letters. This excitement and pride made it far easier to engage them in future fundraising efforts. It is insecurity that keeps many board members from trying to solicit funds.

The second, more potent approach to involving board members in fundraising is to ask each board member to participate in one specific project. Review future projects with individual board members, and try to discern which project really excites them. One board member might be enthusiastic about an educational program, another about a new production, a building project, or a gala.

Ask for their help on the project, and let them get involved—not as staff, but as "godparents" for the project. Let board members meet the performers, designers, directors, teachers, and student interns. Board members are excited to be so close to a project, and this excitement motivates them to ask their friends and peers to become involved, as well. They become wedded to the success of the project, and that is a great motivating factor for fundraising. In fact, it is also the reason staff are motivated to fundraise.

At each board meeting, board members should be asked to report on "their" projects. This gives each adopted project a champion, takes the onus off staff to report on every project, and allows the members of the board to feel closer to the true mission of the organization.

24 ARE WE EMBARRASSED ABOUT OUR ORGANIZATION?

An interesting phenomenon is how board members behave if they are openly—or secretly—embarrassed about the organization. Board members can become embarrassed by their organizations for many different reasons. Many board members are embarrassed by the financial situation of the organization. If the institution is suffering from fiscal distress, many board members do not want to involve their friends. They can

also be embarrassed for other reasons: the nature of the art, the behavior of other board or staff members, the way thank-you letters are written, or the location of the theater.

Board members may be passionate supporters of the organization, but they will not involve their colleagues if they are embarrassed by the organization. They do not want to risk having their friends think less of them when they learn the "truth" about the organization.

A successful not-for-profit organization constantly attracts new people — volunteers, board members, audience members, and donors — and the board should play a crucial role in this endeavor. It plays an especially important role in bringing new major donors to the organization. When board members are embarrassed, they are less likely to bring in others they know. So their potency as board members is reduced substantially.

Therefore, a central role of the staff leadership is to make the board "*un*embarrassed." This is accomplished by eliminating all sources of discomfort, and by getting board members truly excited about the work of the organization and the prospects for the future. If the fiscal situation is poor, show board members how you are on a path toward recovery; if board meetings are contentious, work with the board chair to make them more congenial; if the theater is dirty, get it cleaned. Staff leaders should spend a great deal of time marketing to their boards, without lying, misleading, or hiding challenges from them. Their participation hinges on their being excited about the future of the organization and comfortable that it is being managed well.

If you can talk about programming in compelling ways; get board members to buy into particular projects that engage them; have them believe that you are competent; listen to and act on their concerns; and reassure them about the fiscal health of the organization; then board members are much more likely to be "unembarrassed" and therefore far more likely to help the organization.

A staff leader's job is not only about marketing to the outside, but about marketing to the inside of the organization, as well. A proud board member is a potent board member who is more likely to add major donors, sell more gala tickets, and bring new board prospects to the nominating committee.

Board leadership must work with senior staff to determine whether any board members are embarrassed, and if this embarrassment hampers their desire to fundraise. If so, an internal plan must be developed and

implemented to make board members more excited and impressed by the institution.

25 ARE WE READY TO MOUNT A CAPITAL CAMPAIGN? HOW DO WE PURSUE THIS CAMPAIGN?

Many arts organizations pursue capital campaigns at the wrong time. The campaign might be for a new building or theater, to renovate an existing building, or to create an endowment or cash reserve. All of these are noble ambitions, but too many organizations cannot afford these projects at the time they initiate them.

An organization has to be stable and successful when it starts any special campaign. The programming must be very strong, the marketing campaigns must have created a potent identity for the organization, and the donor base must be expanding every year. In addition, the board members must be so engaged that they want to help make the campaign a success.

If an organization is not functioning this smoothly, mounting a campaign can be incredibly disruptive. Taking the focus off annual fundraising can cause programming to suffer. This can *reduce* interest in the organization, exactly when the organization most needs attention from current and prospective donors. Also, when so much board and staff time is spent planning and executing the campaign, they get little else done — taking the eye off of basic operations can be dangerous.

Too many boards get excited about the goal of the campaign, without adequately evaluating whether the organization is ready for it. The board must judge whether the institutional marketing efforts have been strong enough to create a large cadre of willing donors. Many campaigns have failed because the marketing efforts that are a prerequisite for campaign success have not been planned or implemented successfully. The board must also determine whether the organization can afford a reduction in its annual fundraising efforts. Many donors will make a large campaign gift but then reduce or cancel their annual support. The organization's focus on the special campaign typically directs new donors toward the campaign and away from the annual effort. Therefore, organizations that do pursue capital campaigns must either take a percentage from every

campaign gift for operations, or they must budget for a reduction in annual support.

This campaign challenge to the operating budget can be minimized if the organization is bringing in new donors every year, so that the loss from existing donors is covered by revenue from new donors — or if the campaign is limited to a few major donors. But all this must be evaluated before initiating a capital campaign.

While a building campaign draws donors excited to have their names attached permanently to a new facility, it is harder to attract donors to an endowment campaign, where there is less visibility for a major gift. The conventional wisdom is that if an arts organization has an endowment, it will be financially secure. Everyone, especially board members, would love to have the "guaranteed" income that an endowment generates. Both staff and board also believe an endowment will reduce the pressure on annual fundraising.

Unfortunately, endowment income is *not* guaranteed. As we have seen from recent recessions, the value of an endowment can decline radically when the economy falters. An organization relying heavily on an endowment can see huge cyclical swings in its earnings. The idea that an endowment is a cure-all, or that the institution is safe once it has an endowment, can skew thinking about how to fulfill the mission. Success for an arts organization comes from the pursuit of excellent programming, both artistic and educational. If the organization does not realize this and act upon it, the institution can become stagnant very easily, even if it has an endowment. An arts organization doing a great job with programming and marketing will build an annual effort that supports its work.

Building an endowment is not simple and can put the organization at risk. If the endowment campaign is pursued before the organization is ready for such an undertaking, the organization can suffer greatly. Also, with rapid inflation, the endowment that is sufficient today might not be enough five years from now. Donors to an endowment campaign may believe that a big gift will serve the organization in perpetuity and are often surprised and displeased when they are asked for another gift a few years later.

If the organization does feel prepared for a campaign, it must test this belief by commissioning a feasibility study. A well-mounted study will evaluate if the financial goals of the campaign are realistic for the organization at that time, how much the annual fundraising campaign might

suffer, what proportion of the campaign target will be easily filled by gifts from board members and existing donors — and whether these factors indicate a campaign can be sustained. A list of other strong prospects must also be developed.

A campaign should only be announced after a substantial portion of the goal has already been reached. Most donors to campaigns only give if they are convinced the effort will be successful. If they know that a large percentage of the total goal has been achieved, they are far more likely to give. A well-crafted campaign can change the history of an arts organization. But a poorly designed campaign — or one initiated before the organization is ready — can sap the institution's strength, drain energy from all fundraising, and end in failure.

Board and Marketing

26 HOW DO WE EVALUATE A MARKETING PLAN?

While board members are generally far more involved in fundraising than in marketing, it is still essential that board members understand and concur with the marketing plans supporting both earned and unearned income. Arts organizations that do not pursue smart, integrated marketing efforts are doomed to failure, no matter how good the art is. But for many board members, the marketing plan is simply about attractive brochures and a cute logo.

Marketing activities should be divided into two categories: programmatic marketing and institutional marketing. Programmatic marketing is to persuade people to buy tickets. Institutional marketing is to entice audience members and donors to support the institution.

Programmatic marketing is the central focus of most arts organizations, whose marketing departments thus devote almost all their time and resources to this effort. The prevalent but incorrect notion is that the benefits of marketing are limited to ticket sales. In reality, a balanced approach to programmatic and institutional marketing can have as big an impact on fundraising as it does on earned income.

Programmatic marketing plans must be understood by the board, before it can approve a ticket-sales forecast in a budget. In particular, the board should understand the nature of each production and how that affects the choice of marketing techniques. Although many arts organizations have a template for the way they market each production (for example, one direct-mail piece, three print ads, two e-mail blasts, one radio ad), not every event requires the same selection of media or size of marketing budget.

Some programs are easy to sell: when the artists are famous, or the repertory is popular, it is not a challenge to sell many tickets. These programs require only *informational marketing*, simply announcing the program, the

artists, the dates, and the phone number to call for tickets. The marketing budget for these attractions can be small, and simple techniques can be used: posters, e-mail blasts, and maybe a postcard. Sometimes when these programs are announced, the media attention alone is enough to sell all the tickets.

Other projects are far more difficult. When the work is unfamiliar or the performers are unknown, substantial effort and budget must be devoted to filling the house. Potential audience members need substantially more information. They benefit from seeing photographs and video clips of the performance, and learning about the creators of the work and the performers. This type of marketing is called *missionary marketing*. A good missionary marketing campaign includes a substantial use of public relations activities, web sites, direct-mail pieces, and well-designed e-mail blasts. Posters are usually ineffective to promote a work or artist unknown to ticket buyers, since posters do not offer enough of the information necessary for people to make a buying decision.

While board members do not need to know the details of every programmatic marketing campaign, they do need to know that the staff has correctly evaluated the programs in the season and designed a marketing campaign tailored to each event. The board members must also evaluate the programmatic marketing cost and compare it to the revenue potential. Many arts organizations spend too large a portion of ticket revenue on marketing.

However, board members should be even more familiar with the institutional marketing efforts of an organization, since institutional marketing directly affects the organization's ability to raise money and attract new board members. While board members frequently blame the development department for a lack of fundraising growth, the blame more often lies with a weak institutional marketing effort.

What is institutional marketing? Institutional marketing is anything an organization does to build visibility in the community. That can be major performances or exhibitions, educational activities or special events, announcements of forthcoming seasons or special grants. The impact of the institutional marketing effort depends on the regularity of these types of activities. In today's information-dense world, repetition is the key to getting a message across. The level of excitement generated by the campaign and the number and potency of media reports are also central to the campaign's success.

At the Alvin Ailey organization, the institutional marketing effort featured a series of events reflecting the mission of the organization. These included appearances on television, free outdoor concerts, a museum exhibition about the history of the organization, books published about the company, and a major annual gala. The gala was important and effective because it involved many celebrities — always an asset to an institutional marketing campaign.

These activities were not aimed at selling tickets to a particular show; instead they created the image of the Ailey company as a vital, important institution. In particular, they fostered a favorable impression with the 200 to 300 key donor prospects we were trying to influence. It is important to note that most of these activities had little cost attached to them. Where there were costs, others footed the bill. Institutional marketing often takes time, energy, and creativity, but very little money.

Every organization must assess its own institutional marketing opportunities. What important events are planned? Is there a major artist working with the organization? Is there an element of the work not widely appreciated by the community? Does the organization have an important announcement to make? How can visibility be maximized for each important element of the work?

The goal of a strong institutional marketing effort is to place a spotlight on the many important activities of the organization. When the institution gets known for a range of offerings, it gives potential donors with diverse priorities more reasons to support the organization. Some donors may not be interested in the artistic programming of an organization, for example, but may be willing to support its educational programming. If all of the programming is not highlighted in the institutional marketing effort, there is a danger of losing many potential funders.

For these reasons, a great deal of care should be devoted to planning an institutional marketing campaign. A large institution should have at least one big event or announcement every month; a small or mid-sized organization should have three or four every season.

Arts organizations that maintain vigorous institutional marketing programs are likely to enjoy fundraising success, attract new board members, and see audiences grow — even without additional programmatic marketing. Therefore, boards that spend time evaluating the marketing plans and working with staff to increase the plans' potency, almost invariably enjoy the benefits of both increased revenue and enhanced programming.

27 HOW DO WE GET A DIVERSE AUDIENCE?
A YOUNGER AUDIENCE?

Every comprehensive mission statement refers to the people the organization is hoping to serve. Although many arts organizations have missions to serve diverse communities, many of these same organizations fail to have very diverse audiences. If an institution is serious about achieving its mission and expanding its audience, it must take actions to attract individuals who are new to the organization's programs. In order to engage members of differing communities, the organization must produce the kinds of work that will attract them. It must develop projects that fit in with its artistic leader's vision but also feel more relevant to the audience segment it is hoping to entice.

This can be difficult terrain to navigate. Successful arts organizations lead the audience, not follow it. As projects are created to attract different segments of the community, there must be curatorial reasons for selecting given vehicles; choosing art on the basis of audience appeal is not in line with the missions of most arts institutions.

The programmatic marketing effort must also be tailored to reach desired audiences. When I arrived at Alvin Ailey in 1991, we noted with consternation that our attendees in New York City were predominantly white. Our mission specifically called for us to serve the African-American audience. We knew our repertory was not the issue. Since 1958, when the company was founded by the great African-American choreographer Alvin Ailey, it has always featured African-American dancers performing works focusing on themes from this community. But we found that our marketing focused on advertisements in *The New York Times*, not necessarily the primary source of information for many in the African-American community. We started to use a variety of different newspapers and radio stations and introduced a landmark campaign in the city's subway stations. The demographic makeup of our audience changed instantly.

One of the groups many board members and arts institutions hope to attract is younger people. Unfortunately, there are sociological factors that can make it difficult for people aged fifteen to forty-five to participate in the arts. Certainly, there are people who stay involved in the arts throughout their lives. But many people are busy for decades building

families and careers and do not have the discretionary time or money to participate in the arts. When their children grow older, and their careers have progressed, they typically find their way back to the arts, especially if they experienced them as children. While many arts institutions wish to serve a broad spectrum of the population, they are often serving primarily the oldest members of the community.

It is difficult, albeit not impossible, to attract a large segment of younger people to performances, exhibitions, and special events. However, this cannot be accomplished with gimmicks, including redesigned marketing materials.

When I joined the Kennedy Center as president in 2001, one of our constituent groups, the National Symphony Orchestra, had designed its annual subscription brochure to appeal to a younger audience: words were written on a slant, and pictures were fragmented. It certainly did not look like the marketing brochure of a staid symphony — and it did not work. No new young people subscribed, and we actually lost a large portion of our traditional subscribers, who simply could not decipher the information in the brochure.

One has to create repertory that is enticing to more youthful audiences if one wants them in the theater, just as one can only attract African-American or Latino audiences by producing work that interests these groups. To attract a new audience unfamiliar with your institution takes careful repertory planning. However, developing work that might appeal to younger people risks alienating the traditional audience. Most arts organizations cannot afford this trade-off. Diversification, after all, is about serving *everyone*, not exchanging one group for another. One has to change advertising and repertory selectively, making sure there is still enough programming and advertising targeted to the core audience. At the Kennedy Center, one activity that draws people of all ages, including a large number of young adults, is social dancing, which is now included in every annual calendar of events.

The tools used in a marketing campaign also depend on the age of the audience one is trying to reach. While older people are very rapidly becoming comfortable with social networking and other online communication vehicles, much of the older audience still gets its information from print media and radio. A marketing campaign using exclusively online techniques is not going to reach a good deal of the traditional audience. Young people, however, are virtually all using social networking

web sites, online news services, and texting. Advertising in newspapers will not reach many of them.

There are other marketing techniques that can be employed to attract younger and more diverse audiences. Group sales are a wonderful way to bring in new audiences. When I was general manager at the Kansas City Ballet in the mid-'80s, we developed a relationship with the local Girl Scout troops; this brought in an entirely new, younger audience that we capitalized on for years to come. Similarly, discounted tickets can entice new segments of the population if these groups are targeted in a sophisticated way, that is, through channels they regularly access.

Institutional marketing efforts also help diversify audiences. If we can create the impression that this is the most exciting and important organization in town, we are likely to draw a far more diverse audience than if we relied solely on traditional subscription and single-ticket marketing techniques.

28 ARE OUR TICKET PRICES APPROPRIATE?

Boards and staffs are always trying to find ways to reduce dependency on fundraising, since it seems so uncontrollable. One alternative technique for filling a budget gap is to raise ticket prices. This is particularly attractive to many board members, because they are usually willing to pay more for tickets and assume others are, as well. We once had a board member of great means at American Ballet Theatre. He believed we should double all the ticket prices, because to him the cost of the tickets was irrelevant. For much of our audience, however, price is a very important factor when deciding to buy a ticket. In fact, ticket sales for most arts organizations have, what is termed in microeconomics, a "kinked demand curve." Most industries feature a simple demand curve: increases in price reduce demand by a constant percentage; the steeper the curve, the more price sensitive the buyers. But research suggests that arts tickets are subject to a kinked demand curve, which reveals a steeper angle for low prices and a flatter demand curve at higher prices. This indicates that audience members who pay the highest prices, like the ABT board member, are less price sensitive than those who buy the lowest-priced

tickets. If this is true, then one can raise the highest-priced tickets with impunity, as long as one maintains, or even reduces, the prices of less expensive tickets.

It is essential for every arts organization to research the price sensitivity of its buyers. This is easy to test in the real world by increasing the prices of certain sections and determining whether this has an impact on demand. Of course we want full houses, but we also need to maximize ticket revenue. One has to study to determine how to scale the house, that is, charge differing amounts for different sections of the theater. If some sections are filled while others remain empty, there is something wrong with the way the house has been scaled.

For years, we have lowered prices for certain sections, as we saw that tickets were not selling for an event. Recently, arts organizations have been doing the reverse: testing the concept of value pricing. Value pricing, a method practiced by hotels and airlines for decades, raises ticket prices for very popular events, as the seats sell out. This clearly increases per-house revenue higher than the original budget.

But we must be careful not to raise ticket prices so far that we disenfranchise whole groups of people. If we do, it will be difficult to win them back in the future. Arts attendance is a habit; people get used to visiting a particular arts center or venue. If we lose audience members today, we might lose them forever.

Ticket pricing can also have political implications. In countries where the government provides large subsidies to arts organizations, ticket prices that are too high are viewed as elitist. It is hard for the organization or the government to justify a large subsidy if a majority of the citizens still cannot afford to buy tickets. This was certainly an issue at the Royal Opera House in London: we lowered the prices of many of our tickets and instituted a variety of discount ticket schemes to overcome this problem.

Conversely, we must be careful not to give away too many complimentary tickets. When organizations give out massive numbers of free tickets, they train the audience to expect to be invited forever. This is hardly the way to build earned income. While a few people should receive free tickets, everyone else should pay. This does not negate the value and importance of free performances, which help many organizations reach audiences they might not otherwise have a chance to serve.

The desire to serve particular audience segments really depends on the

Simple Demand Curve

Kinked Demand Curve

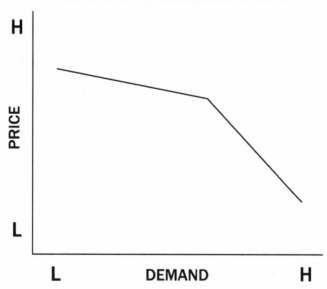

mission. This is another reason why the mission development process is so crucial. If we want to serve a wide range of audience members, we need to develop a pricing structure that allows us to serve everyone.

29 WHY ARE SUBSCRIPTION SALES SO MUCH LOWER THAN IN THE PAST?

Subscriptions have been an integral part of arts marketing strategies for decades because they have multiple benefits. They provide advance financing for performance seasons, since subscribers generally buy their subscriptions months in advance. This revenue can help pay the up-front costs of mounting a season: rehearsing, building sets and costumes, and marketing.

Subscriptions also reduce marketing costs; we do not need to re-market programs to subscribers, and subscribers in turn can generate "word-of-mouth" sales by discussing the programs with their friends and associates. Sending an annual subscription brochure to a subscriber and following up with a telemarketing call are far less costly than the advertising campaign required for single-ticket sales. And the more programs there are in a season, the larger the savings.

Subscriptions also help ensure that even the most challenging works have some ticket sales. When an organization can boast a large number of subscribers, the artistic director has far more programming flexibility, because not every work has to be sold on its own merits. This reduces the risks inherent in programming less accessible work. It is not surprising, therefore, that artistic directors cherish subscribers.

But subscription numbers for most organizations — and genres — have been falling dramatically over the past thirty years. Why is this so? Are arts organizations doing something wrong? The answer is yes and no.

Let's start with the "no." Decades ago, the majority of subscribers to arts events were women. They could predict that they would be available every other Thursday night, for example, for the symphony or theater. Since their husbands did not often travel for work, they knew the men would also be available. Over the past thirty years, as more women began to work outside the home, and more business travel was demanded of many executives, the number of people who could accurately predict their

availability for arts events has decreased. As a result, people are much less willing to commit to a subscription than they were in the past.

In addition, the tremendous inflation in ticket prices charged by many arts organizations has made subscriptions prohibitively expensive for many potential subscribers. A subscription to major symphonies, theater companies, opera companies, and ballet companies can cost more than $1,000 for a couple. This is beyond the means of most segments of our audience. The development of numerous online entertainment alternatives has also affected subscriptions, which have declined steadily, especially for organizations where the number of performances per subscription — or price per ticket — is high.

But for too long, too many arts organizations took their subscribers for granted. Yet there are things we can do to increase subscriptions: many organizations are pursuing more aggressive marketing campaigns. Telemarketing has become far more prevalent. Some orchestras are creating free season-preview concerts, and other presenters are creating and distributing CDs to entice subscribers.

We also need to create more attractive "packages" to engage new subscribers. Numerous organizations have created flexible subscriptions that allow purchasers to pick performance dates to fit their personal schedules; other institutions offer the option to exchange a subscription ticket for another date with no penalties. Pricing strategies are also important. Shorter subscription time frames or partial subscriptions lower the total cost of the package; some organizations are offering deeper discounts to lure subscribers, recognizing the benefits of building the subscriber roster. Existing subscribers should not be taken for granted. By adding benefits for renewing subscribers — including special lectures, events, and discounts — an organization is less likely to lose subscribers by attrition.

Perhaps the most potent technique for attracting and keeping subscribers is to offer special programming that patrons know they will not have access to unless they subscribe. But this can be a double-edged sword. If an organization has a blockbuster attraction one year and uses it to build the number of subscribers, but then fails to offer an equally fabulous event the following season, subscription numbers are certain to fall. So arts organizations that employ blockbuster projects must ensure they are included in every season.

Organizations that make their subscriptions more attractive to buyers and keep current subscribers happy may see some increase in subscription

revenue. But the sociological and economic trends that have reduced subscribers' ability to predict availability or to pay for subscriptions — as well as the increased cost of attendance — are simply too strong to overcome. Subscriptions will probably never attain the levels of the 1950s and 1960s.

30 ARE WE USING THE INTERNET PROPERLY?

The internet is the best friend of the arts. It allows us to get out our messages to virtually everyone, at a far smaller cost than print advertising, television or radio commercials, or direct mail. The basic internet tool is a company's own web site, which can provide performance information, detailed descriptions of artists and repertory, visitor information, donor materials, and educational content. But a web site is only useful if a sophisticated plan is implemented for creating and changing content regularly, and if concerted, disciplined efforts are made to direct people to the web site.

A strong, easy-to-read web site can be a useful vehicle for providing marketing information, but many organizations have poor web sites with information that is not updated or easily deciphered. Studies suggest that one key to a successful web site is to change, update, and add information frequently, so that people have a reason to return to the site periodically. If the web site looks the same from day to day, it quickly loses its marketing power with a large segment of the community.

One needs to experiment to determine how your users use the web site, how they respond to various features, and whether and how often they purchase tickets online. But under any circumstances, a well-visited web site can substantially lower programmatic marketing costs, because it can provide more timely information to potential ticket buyers than any other media. In addition, the organization can reach its audience members at the moment they are making their buying decisions.

The more information you put on your web site, and the easier it is to navigate, the more likely a potential audience member is to purchase a ticket online. In addition to including lists of performances, video clips, audio clips, interviews with artists, and historical information, make the site a place people want to visit. A good web site also increases the organization's chances to sell less accessible works requiring more information

by the consumer. In other words, a web site can be the most helpful tool for projects that require missionary marketing.

E-mail blasts — e-mails sent to large numbers of patrons and potential audience members — are complementary tools. E-mail blasts must be carefully planned; if an organization sends too many, recipients will delete them without reading them. But occasional blasts, sometimes containing a special offer for discounted tickets, can be highly effective, as can e-magazines. Sending e-mail blasts requires a mailing list of e-mail addresses, which many ticketing services and box offices collect. Another way to get e-mail addresses for your audience members, if you do not have access to this information through the box office, is to do a raffle at every performance. Simply ask the audience to fill in a short form with their names and e-mail addresses; a winner is picked at the performance, and prizes can be tickets to future shows, meals at local restaurants, or other items or services donated by local businesses. If you do this religiously, you will develop a strong e-mail mailing list and can communicate with your audience at virtually no cost.

There are other profitable ways to use the internet for marketing purposes. Investigate the effectiveness of advertising in your local paper's on-line edition. In many communities, this can be far more effective than advertising in the hard copy of the newspaper. Social networking sites like Facebook and Twitter can also be very helpful in building a constituency for an arts organization or even a major project. By creating a sense of community, these sites provide a new link between the users, their friends, and the arts organization.

As the means change by which people get their information — whether it is news, weather, sports, or the arts — your arts organization needs to adapt its communication strategies, as well. But like all marketing approaches, web sites and other electronic means must be used consistently and with discipline.

The internet can also be used as an effective distribution network for arts education programming. Educational modules for teachers or students can be easily housed on the internet. This allows users to access and download educational materials anytime and anyplace.

Ultimately, your web site can be the home where your extended family — staff, board, donors, audience members, students, and volunteers — can turn to for information about your organization's events, educational programs, performances, exhibitions, memberships, and tickets.

Boards and staff must evaluate ways to employ the internet effectively and ensure that opportunities for cost reduction through use of technology are being fully explored. Board members can assist with this by asking friends with technical expertise to help the organization develop its online capabilities. Arts organizations unwilling to invest in new technology are going to see their audiences shrink. They will find they are only serving the increasingly small segment of the population that does not get its information from the internet. And, ironically, they will be spending more and more money than necessary to reach smaller and smaller audiences.

31 OUR THEATER IS EMPTY, WHAT SHOULD WE DO?

Too many arts organizations have suffered from insufficient ticket sales and less-than-full theaters. This obviously has earned-revenue implications, but it has expense and fundraising implications, as well. If audience members notice that your venue is never filled, they can wait until the last minute to purchase tickets. This can force the organization to spend more money on advertising and other programmatic marketing than if tickets were purchased earlier. Half-filled or near-empty theaters also affect the audience's experience. Sold-out halls always help generate more excitement. Energy is missing from empty theaters, making it harder for the audience to laugh, to respond, or to feel engaged; the audience wonders if the rest of the world knew something they didn't and stayed away for a reason. If audience experience dictates future purchases (not to mention the incentive to become a donor), then we benefit in many ways from filling our theaters.

There are different approaches to maximizing attendance, depending on whether low ticket sales are a chronic problem or an infrequent one. If this is an occasional issue, one must evaluate if there is a type of programming that causes ticket sales problems. For many organizations, the most adventuresome works are the hardest to sell. While it is true that some kinds of work are harder to market, arts organizations do not help matters by using the same marketing approach for every project. Accessible works require little information and limited marketing efforts; difficult works require far more information. The campaigns for each production must be designed with the nature of the work in mind. More time,

energy, and budget must be devoted to the hard-to-sell works. If present-ing challenging work is a central element of an organization's mission, one has to accept and budget for smaller houses for certain performances. For some projects, offering very low ticket prices, or free tickets to se-lect groups (like students, seniors, or members of the military) may be advisable.

When one gets close to opening night, and the house is not sold, one can pursue a number of options: pushing hard for press coverage can help build ticket sales; so can carefully designed discounts. It is best to adver-tise these discounts through e-mail blasts, since one can control who re-ceives the discount. Discounts offered to the general public through the press can annoy subscribers and those who already purchased full-price tickets. Subscriptions are often the best friend of organizations that have a hard time selling less-accessible shows. One of the great benefits of a large subscriber base is that one is freer to do challenging work, since there are fewer single tickets to sell for each program.

If empty houses are a chronic problem, one must evaluate the qual-ity of the work and especially the potency of both the programmatic and institutional marketing efforts. Poorly implemented or under-powered marketing efforts can result in chronic under-performance at the box of-fice. The staff and the board's marketing committee should assess how much the organization is spending on marketing per ticket sold, and then compare this crucial statistic to that of similar organizations to determine if enough is being spent on marketing .

Also, compare the size of your mailing list with that of similar organi-zations; perhaps your list is too old or too small. Arts organizations that do not invest in regular mailing-list maintenance (eliminating names of deceased people, those who no longer purchase tickets, and duplicate names; as well as updating addresses) end up with chronic cases of poor ticket sales.

Finally, group sales are also beneficial to any marketing executive try-ing to fill a house. Since groups purchase in volume, they can fill large numbers of seats — groups like the Girl Scouts (at the Kennedy Center, we even designed a merit badge for Girl Scouts who came to a show and performed other arts-related tasks), church groups, schools, seniors' resi-dences, and even corporate donors, who can be offered group ticket and subscription rates. Since most corporations have an internal newsletter, they can market the discounted tickets themselves. Even though these

seats are sold at a discount—sometimes a steep discount—these are seats that otherwise would have gone unsold. And for the remainder of the audience, having a fuller house adds to the quality of experience.

32 OUR THEATER IS FILLED, WHAT SHOULD WE DO?

The first thing to do when performances regularly sell out is to celebrate! It is wonderful for all parties involved when the house is filled. The audience members feel the electricity of a sold-out theater; the performers feel that energy on stage; and the organization benefits from increased revenue and lower marketing costs. If an organization is in this fortunate situation, there is no compelling reason to change operational strategies. But there are several questions that should be asked if performances are constantly selling out.

Should more performances be added? If a run of performances sells out, then there is frequently an option to add shows to the run to serve a larger audience. (This might not be an option if performers are routinely unavailable for more performances. But if the season is planned far enough in advance, artists will usually agree to this.) Additional performances can also spread out the cost of creating the production; of course, this is only true if the marginal revenue of added performances exceeds the marginal expenses.

Should prices be raised? The laws of supply and demand suggest that if one is always selling out, there is an opportunity to raise ticket prices. While this may be a good financial strategy (one has to evaluate whether enough of the audience base is willing and able to pay more), raising prices might violate the mission of the organization by disenfranchising a segment of the community that cannot afford to pay more.

An alternative is to raise prices only for certain tickets (typically the best or highest-priced tickets), while maintaining prices of all the other tickets. Many arts organizations are experimenting with "value pricing," that is, raising ticket prices for a show as it begins to sell out. This allows early purchasers to benefit from lower prices, while forcing late buyers to pay a premium.

Should performances be moved to a larger theater? If programs always sell out, this option should be considered. But this analysis must be

completed with great caution: one does not want to add so much infrastructure cost that net revenue is actually reduced, and the amount of art produced is reduced as well. Moving to a new theater can be a costly enterprise. Not only can construction or renovation costs be incurred, but there is also the strong potential for losing audience. So many audience members are loyal to a given theater or location. Moving even a few blocks can affect their decision to attend, in which case substantial amounts of additional programmatic marketing are required.

Institutional marketing efforts must also be enhanced. Organizations with strong ticket sales often forget that they need to continue to pursue their institutional marketing if they want their fundraising revenue to grow. It is easy to be seduced into thinking that strong ticket sales reduce the need for all marketing.

Board and staff

33 WHAT SHOULD WE THINK ABOUT WHEN WE HIRE AN ARTISTIC DIRECTOR OR AN EXECUTIVE DIRECTOR?

One of the five cardinal roles of the board is to hire the senior staff members who report directly to them, typically the executive director and the artistic director. But boards are often so unaware of what it really takes to be successful in these positions that they do not necessarily do a very good job of engaging the best people.

The executive director is an arts entrepreneur who can create great marketing programs, entice new donors, build large audiences, and produce exciting and surprising projects that fulfill the wishes of the artistic leadership. The executive director is also charged with understanding the financial statements and developing and implementing responses to cash-flow problems. These are all highly creative tasks. Yet too many boards are looking for "a safe pair of hands," someone who understands discipline and financial control. Many boards misunderstand the expertise needed by an executive director and hope that hiring a financial executive will improve the financial situation. However, financial executives tend to be experts at *measuring* financial problems, not *solving* them. Solving the financial problems of an arts organization requires someone who knows how to *create* revenue.

Successful executive directors should know enough about each of the operational areas — marketing, programming, fundraising, financial management, and facilities — in order to manage their senior staff, but they may not necessarily be as knowledgeable in every area as staff. Executive directors should feel as if they are on the staff of their department heads. They need to be able to participate in the strategy meetings of each department and offer creative ideas, but leave the final decisions to department heads, who are usually far more knowledgeable about their specific areas.

Executive directors also have to be able to coordinate departments.

Many arts organizations function like a series of silos: those in the marketing silo, for example, do not speak with those in the fundraising silo. Yet the true power of an arts organization is developed when the various departments interact in formal and informal ways. It is the job of the executive director to create a culture in which this sharing is rewarded, and a master organizational strategy that changes over time. A successful executive director must be a strategic thinker.

Executive directors also need to be able to work with the board. They cannot be arrogant or submissive; they must win over board members by creating such a compelling vision and plan that the board wants to support them.

A rich mix of skills is required to be a strong executive director, and unfortunately, there are too few good executive directors to go around for all not-for-profit organizations. So almost all boards have to compromise and determine which skills are most important for their organizations at that given time. For smaller organizations, the job of finding the right executive leader is harder still, since the executive director will probably also have to be the head of marketing or fundraising or other departments, depending on the number of staff and their competence and training.

As hard as it is to find a good executive director, it can be even more challenging to engage an artistic director. Most board members are not fully aware of what the artistic director does or how to evaluate the candidates' skills. (Board members typically have more familiarity with the executive director's duties, since their work in corporations is not entirely dissimilar.) The artistic director is so central to the success of the organization that if board members feel unprepared to hire a new artistic director, they must bring in outside expertise — either an executive search firm or artistic leaders of other institutions who can advise them. And the search committee created to hire the artistic director must include members with diverse backgrounds, at least some of whom have real artistic expertise.

Artistic directors do not simply select plays or ballets or musical programs. They also make sure each season reflects the mission of the organization. They create new and adventuresome programming, select designers and technical staff, find joint-venture partners, develop young talent, and often create art themselves. When experts are not involved in the search process, artistic directors are often hired on the basis of personality, rather than on substantive ability to create interesting programming and an artistic outlook that meshes with the mission of the organization.

While it is helpful to have artistic directors who are popular representatives in the community, it is far more important that they produce work exciting to audiences and donors alike. One vital test for all serious candidates is to ask them to provide a proposed sample season; this will be a good indication of the nature of the work they are hoping to produce. The board members can then determine if this kind of season would work for their organization.

Once you hire an artistic director, you are bound to support that person's art for several years; this can be disastrous if the fit is not correct. In hiring either an artistic director or an executive director, experience is very helpful, but references are crucial. Do not rely solely on the references provided by the candidates; these will almost always be positive. Seek independent views on the skills of the major candidates by talking to board members of the organizations where they have worked, and to others with whom they have collaborated. Past successes and failures are also far better indicators of skill level than educational background.

While sometimes a novice can be a big success, more often than not an experienced manager will know how to enter a new organization and become productive more quickly. Nonetheless, it is better to hire an exciting, talented newcomer than a tired, more experienced executive with a poor track record for success.

34 SHOULD WE HIRE FROM THE FOR-PROFIT SECTOR?

Many boards like to hire from the for-profit sector. They feel that the rigor of the for-profit sector, married with corporate financial discipline, would be welcome in the more "*ad hoc*" world of not-for-profit arts organizations. They also hope that the corporate executive will bring connections from that world that will benefit the institution. There are executives who come into the not-for-profit sector and achieve great successes. These are typically creative, analytical people who can appreciate the differences between the corporate and the not-for-profit worlds.

In particular, they understand the importance of mission to their new institutions and appreciate that a different style of management is required. All not-for-profit institutions, especially arts organizations, re-

quire the good will of large numbers of people. They expect the staff to work for lower salaries than their for-profit counterparts. They ask volunteers to work for no monetary compensation at all. They pay nothing to board members but ask a great deal in return, including members' own financial contributions. Not-for-profit institutions also ask donors for large sums of money and ask audiences to pay increasing amounts to see the work presented. Successful not-for-profit executives must make each of these constituent groups feel welcome and happy to participate. They must be deferential, willing to listen to suggestions and accept criticism, and continue to smile.

This is a very different way of working from what most corporate executives have experienced; they are used to a more hierarchical structure where employees' compensation levels are enough to justify their compliance. Individuals coming from the for-profit sector must be able to make the transition relatively seamlessly to this different mode of managing. First impressions made by new leaders of arts organizations are often lasting ones. They do not have time to learn on the job.

For-profit executives rarely come to the arts with an understanding of the way arts institutions create financial success. Since they may be friends with board members, they probably have heard stories about overspending, over-reliance on fundraising, and a lack of professional management. This can lead new executives to believe that cost control is the greatest need of the organization when this is rarely the solution. And they may be amateurs at creating projects that excite the public and the press.

Many for-profit executives who come to arts organizations are surprised by the lack of support systems, secretaries, and electronic equipment. In an effort to create a more "professional" environment, they may spend a lot of money on infrastructure — money that should be spent on programming.

Other for-profit executives try to compensate for their lack of knowledge by bringing in outside consultants. The notion that one has to "spend money to make money" is not really applicable in the not-for-profit world. Arts organizations are used to getting resources donated so they can make money! Sometimes board members are recruited to serve as executive directors; this almost always ends in disaster for similar reasons. And because the new executives were peers of the other members, it is harder to ask them to leave if they do not do a good job.

A warning: If a new for-profit executive, or any new hire, suggests that

staffing is inadequate and must be strengthened before new revenue can be generated, be wary. Revenue creation must actually *precede* new staff hiring; someone from the outside might not recognize this and might have the mistaken notion that new staff will immediately increase revenue. This rarely happens.

All of these comments are meant as cautionary advice; the fact that candidates come from successful corporations does not necessarily make them ideal candidates for executive positions at arts organizations. The board of directors must test candidates thoroughly to make sure the organization does not fall into this trap.

35 IS IT APPROPRIATE FOR BOARD MEMBERS TO DO THE WORK OF THE STAFF IF THEY ARE NOT DOING IT WELL?

In many troubled arts organizations, board members appropriate the work of the staff and do it themselves. This may be a subtle shift of responsibilities that has staff approval, or a wholesale takeover of the work of one or more departments. This typically only happens in two situations: a board member wants to be on staff (as I did at The Washington Opera in 1985), or board members believe staff are not competent enough to do their jobs correctly.

In the late '90s, when I took on the leadership of the Royal Opera House, it was in such disarray that the board members believed many of the staff to be incompetent. At their weekly meetings, board members even edited press releases to be issued that week. This was neither a good use of the board's time, nor good for the morale of the staff. This was clearly not an ideal scenario.

Board members may believe they can do the job better than staff members, and sometimes they can — for a period of time. But generally, staff members have knowledge that board members do not; and over time, the board members come to appreciate the constraints that bind the staff. Arts organizations are more complicated than many board members believe. Because budgets are relatively small, there is a mistaken notion that there is not much they need to know to do the work. This is certainly not the reality.

Also, most board members who "become" staff do not really want full-time jobs. They usually have other professional and personal commitments that they can ignore for a limited period of time while they are consumed by the work of the arts organization. But at some point, these other obligations must be attended to, and the board members may disappear for days or weeks at a time, leaving the arts organization in the lurch. If staff members are not competent to do the work, they should be replaced. But board members have to be careful not to jump to conclusions. It is often the best workers that the board would like to let go.

When I came to American Ballet Theatre, several board members indicated that a certain employee had to be fired. They believed he was not good enough at his job. After working with him for several weeks, I realized he was actually an extraordinary talent. But he had grown depressed from the lack of vision at the top of the organization; every time he had an idea, he was told there was no money to implement it, and he simply stopped trying.

Before board members attempt to poach the work of the staff, they need to understand what is really required. Too often, board members assume that people working in arts organizations are incompetent, and that if they were competent, they could work in the for-profit sector. In reality, great sophistication is required for fundraising, marketing, financial management, and programming in arts organizations.

The relationship between the board and the staff is a delicate one that must be handled carefully and maturely by both the staff and the board leadership. The board is clearly in charge: it plays an oversight role; it must approve all major expenditures, budgets, and plans; and it hires, fires and compensates the staff leadership. But these duties must be handled in a way that acknowledges that the members of the staff are professionals in their field, and that the board members typically are not. Because board members frequently have leadership roles in their own institutions or corporations, they believe they can simply transfer familiar methods and modes of behavior to the arts organization. But board members have far more expertise running their own businesses than they do running an arts organization. So humility is essential in the board's relationship with staff. The board chair can play an invaluable role by demanding that the board respect the staff and relate to them in an appropriate manner.

Similarly, staff leaders must accept that the board is boss. They must be able to teach the board the realities of important constraints and oppor-

tunities in the organization, without seeming arrogant or condescending. Staff leaders must also inspire board members to become collaborative and generous. If staff members are secretive or withhold information or do not share ideas with board members, they are preventing the board from being helpful and involved.

The board is a group of volunteers that has the potential to be extremely constructive, or to become helplessly inert if it is not handled properly. Staff must also appear in control of their work. They must "own" all pertinent information and be prepared to propose solutions to every problem. If staff, at any level, vent to the board without offering concrete solutions, they will not be viewed as competent. Every time staff members do not have a solution, they are inviting the board to come up with its own solution. And the staff may not like the outcome. This is particularly true during a time of crisis. When the staff comes to the board and complains about cash-flow problems, for example, the board is forced to become the leaders of the institution and solve the problem.

In smaller organizations, the balance of power tends to shift naturally towards the board, since the staff may be inexperienced, may not have time to do everything, or may not exist at all. In many smaller or younger organizations, the staff members are likely to be artists with no real training in executive matters. As the organization grows, the staff comes to have a bigger managerial role. In the largest organizations, boards play minor managerial roles, because sophisticated, well-paid staff handles all but the most critical issues without advice from the board.

36 HOW SHOULD THE ARTISTIC DIRECTOR AND THE EXECUTIVE DIRECTOR RELATE TO EACH OTHER?

Many organizations have both an artistic director and an executive director. They are coequal, and both report to the board. This can be a confusing management structure to many corporate executives who are used to one CEO of an organization. But this structure is highly advisable when the artistic director spends a great deal of time making art. For example, in most dance companies the artistic director is also a choreographer, and in symphonies the music director (artistic director) is also the conductor. The artistic director of many theater companies is also a stage director.

These artists devote a great deal of time to creating projects, casting, rehearsing, collaborating with designers, and performing. They do not have the time, or often the expertise, to run the institution's administration.

It can be advisable to split the leadership roles even in those organizations whose artistic leader does not make art; the knowledge required today for each function is so sophisticated that rarely can any one person manage both sides of the house effectively. But there are challenges. When there are two leaders with differing portfolios, there is room for conflict. The artistic director wants to create great art; the executive director wants to show great fiscal results, audience size, and fundraising revenue.

These two different sets of goals frequently cause conflict. The artistic director may want to stretch the organization's program and do more difficult, challenging, or expensive work. The executive director, fearful of the organization's ability to sell this work to audiences and donors, pushes for more accessible and less costly work. This is not an unhealthy tension unless it becomes unmanageable: the two "sides" stop collaborating; the artistic side stops being as creative as it should be; or the board is called in to referee because the two antagonists cannot come to an agreement. If the board is asked to resolve a problem between the artistic and executive directors, there is a serious problem in the organization.

Even though the two leaders are coequal, the solution virtually always lies in the mission of the organization, which is about art and not about commerce. The executive director's job is more about fulfilling the vision of the artistic director than about showing a strong balance sheet. However, it is also the executive director's job to structure the wishes of the artistic director into an affordable and achievable multi-year program.

This is one major reason for a five-year artistic plan. It allows the executive director to schedule the various programs specified by the artistic director in such a way as to make them work within the budget over this time period. Otherwise, the artistic director can act like a naughty child and the executive director like an angry parent. The child says, "I want this; I want that," and the parent says, "No, we can't afford that."

This kind of relationship is entirely unhelpful and unsustainable. When executive directors make it clear that they are on the same side as the artistic directors, a truly healthy relationship can form. And artistic directors are more likely to actively help with fundraising when they

believe their programming will benefit. This symbiotic relationship, in which both people respect each other's skills, is a joy to observe. The organization can benefit from the substantial and unique expertise of both partners, and the organization is stronger because appropriate skills are brought to bear in every situation.

Board and Planning/ Budgeting

37 HOW SHOULD WE APPROACH A STRATEGIC PLANNING PROCESS? HOW CAN WE MAKE SURE THE PLAN IS IMPLEMENTED?

The strategic planning efforts of many arts organizations suffer from not having a "plan for planning." Board and staff members may gather in a room to discuss a series of important topics and hope their conclusions coalesce into a meaningful plan. Usually these planning exercises are time consuming and frustrating, and allow the loudest voice to have the biggest impact.

This approach tends to result in a list of goals, rather than an integrated strategy for the organization. Often, the "plans" are little more than promises that everyone is going to work harder to do better marketing, raise more money, and sell more tickets. These strategies are virtually never implemented. The time expended and aggravation caused by this approach frequently causes "planning backlash" — the sense that less planning would have been better.

Avoiding planning backlash is relatively simple; it requires that two key agreements be reached before planning commences: the first is to agree on a conceptual framework for discussing the plan. This framework, or logic flow, allows the discussion to unfold in an organized, logical fashion. The second is to determine an efficient planning process that will result in the best plan for the organization.

The framework is straightforward: it begins with the mission. The mission statement guides the organization and reveals what the plan should accomplish, and how the organization will measure success. Once the mission is developed, the environment in which the organization operates should be explored to determine what it takes to be successful. Are there other organizations in the region doing the same work? How does

this influence the ability to generate earned and contributed revenue? Are particular suppliers causing costs to rise rapidly? Are substitute products making it more difficult to attract an audience? Evaluating these issues, and then discerning the factors required to address them, reveals the keys to success in the industry. Are they a strong product, a strong staff, a strong board, strong relationships with artists, a strong touring program, or some combination of these?

The internal analysis suggests whether the organization possesses the factors identified for success. If it is crucial to have a strong community presence, for example, does the organization have that presence? If it is vital to have a comprehensive education program, does the organization have that program?

Arts organizations often collect reams of unnecessary data for the external and internal analyses. This planning framework eliminates the need for lengthy, unfocused data collection efforts, though some data is required about competitors, suppliers, buyers, and internal strengths and weaknesses.

Once it is determined what it takes to achieve the mission, and whether the organization has those success factors, strategies can be developed. Rather than a random list of ideas, the strategies should address the analyses described above. If the organization has a given success factor, the strategy must be focused on maintaining that advantage. If the organization is missing a certain success factor, the strategy must address how to erase that deficit.

This approach makes strategizing direct and focused and eliminates the "loudest voice wins" from the planning process. It allows for a logical discussion of goals, situations, and strategies. Once the strategies are created, an implementation plan is developed that details how each strategy will be pursued, who will be responsible for it, and when it will be completed.

Finally, a financial plan can be developed. This should forecast how the organization's income sheet and balance sheet will look in the years ahead if the strategies are pursued as delineated. This forecast is essential. The organization must know whether the strategies being planned will yield financial results good enough to maintain operations and to continue to pursue its mission into the future.

It is meaningful that the mission and the financial results "bookend" the plan. The mission sets the goal and determines how the organization

Strategic Planning Framework

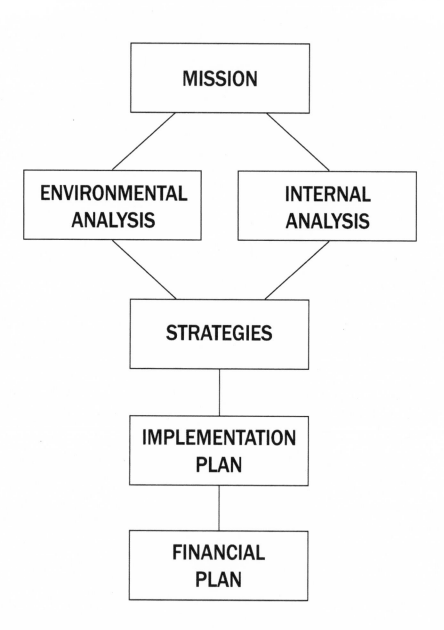

will measure success. The financial plan indicates how one crucial element required for pursuing the mission—financial stability—can be ensured. But the financial plan is not the mission; it is a prerequisite for achieving the mission.

This framework helps guide the process and suggests a series of meetings that can result in a realistic plan in an organized, timely fashion. It is also helpful to establish a planning committee for this process. The committee should include key board members, senior staff, and artist representatives.

Each meeting is devoted to one element of the plan. The first meeting is devoted to discussing the mission of the organization. If the mission does not exist, serious work must be undertaken to develop one, and to have it approved by the full board before the remainder of the planning process is pursued. Once the mission is completed and accepted, separate meetings should follow for the external analysis, internal analysis, strategies, implementation plan, and financial plan.

This approach to the planning process does not employ a board retreat, a standard element of many organizations' planning processes. A typical retreat brings together board members and a few senior staff members to a meeting place, often a resort or hotel, for a couple of days to discuss the strategic plan. Board retreats are popular for two reasons: they give board members a chance to get to know each other and build a sense of common purpose, and they can be an efficient way to develop a strategic plan. Board retreats are fun and give people a chance to bond. Any time spent away from the daily crush of business is helpful to creative thought.

But while retreats make the planning process efficient, they very rarely result in an effective plan. Planning takes time—to collect data, to collect thoughts, to be creative. When an effort is made to develop a plan in two days, it usually results in a superficial document filled with hopes and dreams, but lacking specific, well-considered, creative approaches to solving problems and achieving goals. Retreats also take up so much time that many board members will not make themselves available for other important board activity for days or weeks after the retreat concludes. Also, the most potent board members are often too busy for retreats. (It is better to have a board of very active people who cannot set aside two full days for the organization, than board members who have lots of spare time.)

Whether there is a board retreat or not, one person must lead the planning process. This leader is responsible for collecting the required data

and drafting each proposed section of the plan, a week or so before the relevant meeting. The members of the planning committee should review the draft before each session and use the meeting time to review, challenge, and amend the elements of the draft section.

The leader of the planning exercise is then responsible for redrafting that section and sending out the next section. There may be significant time between meetings to allow the leader to gather data from staff, board members, and others. This entire planning activity should take place in a relatively concentrated time period — maybe two or three months — and not spread out over a year. If it takes too long to create a plan, the common understanding and direction of the committee can easily be lost.

Clearly, the leader of this effort plays a major role. It is often useful to split this leadership role in two, with a board member acting as chair of the committee and presiding over meetings, and someone else with planning expertise writing the drafts. This structure allows the board member to be an impartial facilitator during the planning meetings.

Many arts organizations engage a planning consultant to help develop the strategic plan. It is preferable, however, for an organization to do this itself. Why? Because it is expensive, and too often the plan ends up being the consultant's plan rather than the organization's plan. Nevertheless, since there is a need for experience and skill in developing a plan, the organization must evaluate whether it has a person, or people, knowledgeable enough to lead this process. If no one in the organization knows the proper procedure for creating a plan and the elements of a good plan, and no one has the experience to write a plan, outside help is important. When the planning process is led by someone with little experience, the result is likely to be a bad plan, an inefficient planning process, or both. If the organization cannot afford a consultant, a local corporation can be asked to provide someone with planning experience as a contribution.

Whether the plan is developed with the help of a consultant or not, it is very useful to have outside people read the plan and evaluate it once it is drafted. Often an organization thinks a plan is satisfactory, but an outside reader may find inconsistencies or a flaw in the logic. An outside reader can also objectively observe if the plan is not truly addressing the organization's key needs, if the strategies are really a set of wishes, or if the implementation plan is weak.

Too many organizations create strategic plans and then do not implement them. This can be the result of a lack of discipline. Some organiza-

tions' participants are so tired at the end of the planning process that they believe it is time to relax, when the plan actually generates a great deal of work to be completed. But there is a way for boards to encourage implementation — through the use of an implementation plan.

An implementation plan begins by breaking every strategy into a list of tactical steps. This is helpful because even though the strategy may make sense to everyone, there may not be general agreement about the best ways to accomplish the strategy. (As in all planning, clarity is key to successful implementation.) Then, someone is assigned responsibility for accomplishing each step. This may be a staff member, board member, volunteer, or artist. This person is selected because of their expertise, position on staff or board, or because they have available time.

Finally, a completion date is assigned to each step. Some steps will be ongoing, (for example, building relationships with key government officials), but most steps should have a specific time by which they must be finished. When the implementation plan is completed, the board and staff have a valuable management tool.

The information in the implementation plan can be sorted by the name of each person responsible for accomplishing each tactical step. This reveals whether any one person has been assigned too many things to do. If so, either some tasks must be reassigned, or additional personnel is required. This sorting also provides a clear strategic work plan for every board and staff member.

The information can also be sorted by date. This provides a calendar for implementing the plan. Staff leaders can use this calendar to ensure that the implementation is proceeding as expected. The board can review the calendar at every board meeting to ascertain that the steps planned to be implemented by that meeting date were successfully completed.

If a task was not finished, the board can determine why it was not, and how the delay will affect future planning. This builds accountability into the planning process. When the plan is not implemented, and there is no movement in the fortunes of the organization — after a great deal of effort went into creating the plan — planning backlash is sure to set in. But consistent, successful implementation reveals that planning truly helps an arts organization make progress.

38 DO WE REALLY BELIEVE THE BUDGET WE JUST PASSED? WHERE SHOULD WE CUT IF WE NEED TO?

One of the biggest concerns about arts boards is that they approve annual budgets without really grasping the underlying assumptions. The board members who do understand numbers will look for reasonableness: do the increases in annual revenue and expense seem to make sense? But they quite often make this judgment without a true comprehension of the plans of the organization. Can the programs be created at the expense levels set in the budget? Are the programming and marketing exciting enough to achieve the earned-income budget? Is the growth in fundraising revenue justified by the strategies of the organization? Does the board really understand how the organization plans to build a larger "family"?

The annual budget is so important that there must be a basic understanding of each major expense projection and how it was derived. There must also be an evaluation of every source of revenue to make sure that a systematic bottom-up approach was used to create the forecast. First the finance committee and then the full board must do due diligence to understand the budget before approving it.

The finance committee must also monitor the staff's track record of budgeting success. Some organizations do a remarkable job of budgeting; they stay within expense budgets and meet or exceed revenue projections with great regularity. Some staffs always pad the expense budget; they save money against the budget every year because they add a safety buffer to every account. While boards may appreciate organizations that always do better than budget, they must be careful of this strategy. The mission of every not-for-profit organization is related to the quality and quantity of its programming. When a budget is always padded, the quality or quantity of the actual programming may be less than could have been delivered. Does the staff always overestimate revenue? Evaluating past budget competence can inform the level of scrutiny required by the board.

Heightened scrutiny is especially important for an organization in transition. For a presenter that is expanding its programming substantially, or one that is creating a new facility, board scrutiny must rise to a new level.

For example, the majority of organizations planning a new building underestimate the cost of occupying the new facility. This can be dangerous; the first year after the conclusion of a capital campaign is not the time to solicit emergency operating grants.

One of the challenges of budgeting in the arts is that costs go up so quickly. Expenses rise more rapidly than in other industries, because the arts have such difficulty increasing productivity. In virtually every other industry, the impact of inflation is mitigated to some extent by improvement in worker productivity. This is why productivity is such an important measure and is studied so carefully by economists.

But in the arts it is almost impossible to improve worker productivity. The largest single cost is usually artistic personnel, and the need for these workers cannot be reduced annually. It takes the same number of actors to perform *Hamlet* now as when Shakespeare wrote it. And Beethoven's *Fifth Symphony* cannot be played faster every year. As a result, the arts do not enjoy the help with inflation that other industries experience. Some modest productivity gains can be achieved backstage with new technology (although this often leads to more sophisticated productions that end up requiring more expense). And there certainly have been gains in productivity in the office with the advent of computers, internet, and communications technology. But the costs of these forms of labor tend to be dwarfed by the cost of artistic personnel in most arts organizations.

Those organizations with the most artistic personnel see the highest growth in labor costs. Symphony orchestras, for example, are characterized by a high number of artistic personnel, so their costs rise very quickly. Arts organizations that do have the flexibility to perform with fewer artists can achieve some measure of increased "productivity" by producing works with fewer roles. Theater companies are able to reduce artistic labor costs by producing smaller works. Unfortunately, this has led to a number of very small seasons featuring more minor works. While this can make economic sense, it rarely makes artistic sense over a long period of time, and limits the repertory that many companies produce.

This problem with productivity is compounded by the economic truth that once a theater is selected, the real earned-income potential is set in concrete. There are only so many seats to sell for each performance, and once they are sold, the limit of earned income is reached. This means that while costs rise rapidly, owing to low levels of worker productivity improvement, real revenue remains the same. Therefore, the gap

that is created between earned revenue and expenses continues to grow. This income gap is the central challenge facing arts organizations across the globe.

It is the central challenge that arts boards must address — how to fill the gap between earned revenue and expenses. The solutions that have been developed are limited: raise ticket prices, raise government funds, look for auxiliary sources of income, and raise private contributions. Each of these approaches is fraught with challenge. When ticket prices are raised consistently (as they have been over the past thirty years), many potential audience members are disenfranchised. No wonder the arts are called irrelevant by many. This problem is exacerbated by the growing presence of electronic substitutes. When one can buy a computer for the price of two tickets to a major opera company performance (as one can today), it becomes increasingly attractive to stay home and watch YouTube.

It would be wonderful to get more government support, but that is unlikely to happen on a consistent basis, in any country in the world. Arts organizations that rely too heavily on government funds tend to suffer from swings in political interest. In any case, most countries are reducing the level of support to any given organization as the need to fund other social programs is growing, and the number of arts organizations eligible for government support grows.

Many board members believe there are ways to earn income apart from ticket sales. Although some arts organizations make good money on retail sales, space rental, and food, precious few earn enough to make a real dent in the income gap. There is simply not enough demand for mugs, umbrellas, or videos to make large profits.

The final approach — raising private funds — is the most satisfactory in the long run, though it is often the scariest to board members. A well-run arts organization that produces great art, markets it aggressively, and has a strong, functioning board can almost always build on its contributed revenue and fill its income gap.

Most arts organizations must still find ways to cut their budgets at some point. This is not always evident to board members, who typically see the budget only after it has gone through several iterations. Every arts organization tends to grow to a point that is uncomfortable, since it wants to do more to achieve its mission than can necessarily be afforded in a given year. The initial budgets submitted by each department almost al-

ways result in an organizational budget that is unaffordable. So budget cutting is essential.

Frequently, the board is brought into the process when the staff cannot balance the budget, or when the board is concerned there is too much optimism in the revenue forecast. And when the economy experiences a downturn, boards and staff quickly understand there is a need for cutting some expenses.

But where does one cut? Too many arts organizations cut programming first, because it is discretionary and does not require eating into the infrastructure. But when one cuts programming, one also cuts the organization's revenue generating capacity, for both earned and contributed income. Putting infrastructure ahead of mission is rarely a successful strategy.

It is preferable to cut everything *but* art and marketing—anything that does not create revenue. Costs for staff travel and training, the annual gala, and office equipment, for example, must all be evaluated for possible reduction. One traditional area of expense cutting that must be approached with great sensitivity is staff salaries. Staff members of arts organizations generally earn small salaries; they are willing to do so because they have the psychological reward of working for an organization whose mission they support—often passionately. Since board members volunteer their time, they sometimes forget that the staff relies on their salaries to live. Slashing salaries or eliminating raises demoralizes hardworking staff members and may force them to evaluate other career options.

Some organizations need to "right size." These are the organizations that try to do more work than they can support, year in and year out, building deficits that threaten their survival. They must decide what the right size is: how much revenue can reasonably be earned and contributed? How much programming can therefore be afforded? And what will make this programming exciting and vigorous, even if there is less of it than before?

The board needs to understand the difference between an organization going through a rough patch and an organization that is too big to be affordable. This can be accomplished by determining whether the deficits are sustained annually. If they are a one- or two-year phenomenon only, then the organization probably does not need to reduce in size. Rather, the organization needs to improve revenue generation through better

programming or more aggressive marketing. But if the organization has a deficit every year, or relies for its survival on extraordinary annual gifts, such as bequests, then the organization is probably too big.

39 SHOULD WE BUILD A NEW FACILITY?

Too many arts organizations have "edifice complexes" — they want to build, build, build. There are many legitimate reasons for a new facility: an existing museum or theater may be outmoded or of inadequate size; offices may be cramped for a growing organization; studio space may be insufficient and require the organization to rent additional space; or collection areas may be too small.

Built at the right time, a new facility can be a landmark event for an arts organization. It can energize audiences and donors, facilitate the creation of better art and larger education programs, and provide an arts anchor in the community. When is the right time?

- When the organization has such a strong annual funding mechanism that it can afford to divert its attention to a capital campaign
- When the organization's programming and marketing are so strong that a growing number of people want to be involved with the organization
- When the board members are so committed that they are willing to give generously to the building campaign, and involve their friends and associates in the effort to fund the new structure
- When the organization fully appreciates how the operating budget will change when the facility is completed, and is dedicated to finding the additional necessary resources
- And when a smart plan has been developed for the facility, for the required capital campaign, and especially for the way the organization will inhabit the new building

Many organizations plan right up to the moment the new structure will open, but devote too little time planning how the organization will live and operate in the new building: create more programming, attract larger audiences, and increase contributions. When the institution is functioning well in all areas, the construction of a new facility can be a

remarkable boost to its growth and performance. But many building efforts are pursued before these conditions are met. As a result, the tension inherent in any large, expensive project begins to unmask the underlying weaknesses of the organization.

Many arts organizations like building projects because they appear to be natural magnets for funding. But mounting a capital campaign before the organization is ready is foolhardy; the arts world is littered with unfinished or unsuccessful capital drives. If the institution has not built a large, growing, and generous constituency, it will be unable to attract enough funds to both finish construction and continue operating during the construction period.

Even if the funding required for the building is obtained, it is far harder to generate the *annual* funding required to operate the new, larger facility. So many arts organizations have become "house poor." They do not adequately estimate the costs of the new facility, which include not just the cost of operating, but also the expenses incurred by increased programming to fill the new space, and the additional marketing required to attract audiences to the larger house or longer season.

It is a shame when an arts organization has to *reduce* programming in order to pay to operate the new facility. The mission of virtually every arts organization is focused more on programming than on facilities. Certainly, the cost of lighting and air conditioning are not related to the work and mission of the organization. When an organization sacrifices programming quantity and quality for a new facility, it is not adhering to its true mission statement.

40 WHAT ARE THE MAJOR PITFALLS OF PLANNING WE SHOULD AVOID?

Over a period of decades, planning has gotten a bad reputation with many people. The feeling that planning takes too long, returns too little, is never implemented, and is only performed because it is "good for you," is commonplace.

This is unfortunate, because planning is essential for arts organizations. Since they are commonly under-resourced and cannot afford to waste one minute or one dollar, good planning helps save both time and

money. An arts organization without a strong plan is liable to see informal factions of board and staff pursuing multiple strategies; this is never efficient. And an arts organization with no plan cannot consistently create the large multi-year projects that will change the image and the history of the organization.

Yet despite the value of good strategic planning, there are many planning pitfalls that can lead to "planning backlash," the sense that less planning is better than more. This backlash is virtually always a result of poor planning—either a planning process that did not work effectively and efficiently, or a planning output that was not useful. Avoiding a series of planning pitfalls maximizes the odds of avoiding planning backlash.

Many organizations pursue planning processes that are poorly designed, too complicated, take too much time, and do not use a framework or roadmap to guide it. A framework is a logic flow; it makes the process efficient because it clarifies what is being studied and why, and how it leads to the next set of insights. Without a framework, the planning process becomes a jumble of ideas and data; this extends substantially the time it takes to sort out the proper plan for the organization.

But even some organizations that use a planning framework forget that the sections of the plan should be linked by logic. Too often, one section of a strategic plan does not lead naturally into the next; turning the page to begin the next section is like starting an entirely new book. A good plan reads like a novel; one chapter leads to the next. This is essential if the plan is to be memorable. And a memorable plan is one that is far more likely to be implemented.

Many organizations also forget that the mission statement is the motivation for any plan. Without a clear set of goals, it is impossible to create a strong plan. Unfortunately, when the true mission is not used as the motivation, the plan almost always focuses on financial stability, rather than artistic or educational success; the plan then becomes suspect to the artists and board members who focus on artistic accomplishment. In many organizations, the planning process concentrates more on data collection than on insight generation—a classic planning error. And many organizations are more concerned with a nicely bound planning "book" than a comprehensive, coherent, implementable plan.

A good planning process does not focus on forms, data collection marathons, or spreadsheets. While a good plan does require some solid data, it is not true that the more data collected, the better the plan. The best

planners use data to support or refute hypotheses about the causes of success and the optimal paths toward the future, not as proof that a thorough job was done. It is also untrue that the more meetings held, or the longer the meetings, the better the plan. A good plan should be developed over a period of two to three months, with four or five meetings of the planning committee.

A good plan cannot be developed in a two-day board retreat. Planning retreats rush a process that should allow ideas to germinate. Planning takes creativity and must result in insights. This cannot be achieved in a weekend; nor can an entire board develop a plan while sitting in a room together. No thoughtful, integrated plan can be created by twenty or thirty people at a time; the plan just ends up being an agglomeration of ideas, rather than a coherent, comprehensive strategy. Also, when so many people try to meet together, it is often the loudest person who "wins," rather than the most insightful. This cannot be optimal. And the data that is required is often not available during the retreat, so everyone starts making assumptions. Over a period of hours, the assumptions come to be thought of as facts. This can lead to erroneous conclusions.

So many plans for arts organizations detail extensive strategies for marketing, fundraising, financial management, and board development, but omit one crucial element: the art. It is hard to imagine how one can formulate plans for marketing, for example, that are not based on the work the organization is hoping to accomplish. A good plan must include a multi-year menu of projects the organization is planning to develop.

But the biggest pitfall is developing a plan that is just a set of hopes and dreams, and not an implementable strategy. Too many arts plans are simply an expression that the organization will work harder in the future, without specific programs for increasing the artistic and financial strength of the organization. Writing, "We are going to strengthen our board," is not a strategy; it is a wish. Most plans also lack an explicit implementation plan — a list of tactics required to achieve each strategy, an assignment of responsibility to someone specific for accomplishing each tactic, and a time frame for completion. Without this information, it is unlikely that the plan will ever be implemented.

Board in Crisis

4I OUR ORGANIZATION IS IN A CRISIS, WHAT DO WE DO?

The first thing to do when it becomes clear that an organization is in crisis is to relax. Do not panic. No arts organization can get into too much trouble, since no one will lend it very much money. Arts deficits are usually less than a few million dollars—a lot of money if one does not have it, but not a lot of money in the context of the economy of a city or state.

In almost every instance, the solution to a financial crisis is to find additional revenue, fast. While it is natural for boards and executive staff to hope that cutting costs will solve the problem, this is rarely the case. Arts organizations that try to "save their way to health" almost invariably end up sicker. The cuts to the budget almost always result in reductions in programming and marketing, which lead to reductions in earned and contributed revenue, which increase the organization's deficit, which leads to even more cuts. When this cycle is allowed to continue, the organization gets smaller and smaller, sicker and sicker, and less and less relevant to the community.

Of course, some costs must be cut, but it is essential to focus on cutting those non-strategic costs that will not affect future revenue generation. (There are some organizations, whose budgets are not sustainable by their revenue streams, that do need downsizing. These are typically organizations that survive for years on extraordinary income, including one-time grants or bequests. When these revenue sources disappear, serious problems develop. But the number of these organizations is relatively small.)

If revenue generation is the key to fixing a troubled organization, then the board and staff must remember that what creates revenue is good programming, supported by strong marketing efforts. Prospective donors must be excited by the future of the organization and comfortable that the leadership has a plan for fixing any momentary financial problems.

Yet arts organizations in crisis virtually always do the opposite: they cut programming and marketing. And to make matters worse, they talk so publicly about their problems that donors, audience members, and the press lose confidence in the organization. It is essential to keep public communications positive and focused on the achievements of the organization and the contributions it makes to the community. It takes discipline to focus on the positive when one is feeling cash-flow pressure, but this is crucial.

While the crisis almost always leads to numerous views about how to solve the problem, the organization must create one single plan of action. Allowing various board and staff members to try to fix the problem with their own strategies ends up wasting resources and presenting a picture of disarray. Board and staff leadership need to pull together at this time, with a unified vision for the future. Otherwise, no serious donors will be willing to invest in the future of the troubled organization.

This plan must demonstrate how the organization will resolve its financial problems incrementally, while allowing the organization to maintain, and even build, its programming. Financial problems rarely have to be solved all at once. Too often a board and staff will set a target for solving the entire financial problem in a very short period of time. This can be daunting and dispiriting, and can make potential donors feel like the mountain is too high to climb. It is better to evaluate how much extra has to be raised for the next month or two or three, and resolve the issue bit by bit. As one starts to make progress, constituents gain hope that the problem can be solved. This new confidence is crucial to the turnaround since it leads to new gifts, better press, and improved morale. As board morale improves, the willingness of board members to raise funds increases exponentially. So it is critical that the organization celebrate each step towards the eradication of the problem. Indeed, a turnaround is ninety percent psychological.

An additional tool that can help build everyone's confidence is a challenge grant. If a donor is willing to make a large pledge that must be matched by new contributions or by increased gifts from existing donors, it has dual benefits. The fact that someone is confident enough to make a large pledge builds excitement and hope. But a challenge grant also encourages additional contributions, because each gift is essentially doubled by the donor. If you cannot find a donor to make such a grant, package together the pledges of several donors into one challenge grant.

Or, as we did at American Ballet Theatre, ask a major donor to combine multiple years of gifts he will make anyway, and call it a challenge grant. Peter T. Joseph, the chair of American Ballet Theatre in the mid-1990s, packaged five years of his gifts into one five-million-dollar challenge grant that changed the history of ABT. The money raised to match his challenge erased the entire accumulated deficit of the company.

Of course, there are crises other than financial. Some arts organizations find themselves in an artistic crisis when the art of the organization is simply not good enough. This almost always leads to a financial crisis, so fixing an artistic problem early can save a great deal of anxiety and pain later on. The board must analyze if enough of the annual budget is being devoted to making art. Many organizations starve the artistic function; this never results in good art or, ironically, a fiscally sound organization. Other institutions lack the artistic leadership required to take the organization to the next level of excellence. If this is the real issue — and one must be very careful to make sure it is — the artistic leader must be replaced.

Other organizations experience public relations crises created by such things as staff or board impropriety, poor fiscal results, controversial art, or safety problems. The list of potential causes of a public relations problem is endless. If the issue is relatively minor, or the press attack is limited, the best solution is to fix the problem but not to respond to the press. A response keeps the story alive. If a journalist writes one negative story, and the organization responds in the press, it gives the journalist the impetus to write a second story. This cannot be helpful.

If a major problem exists and the press is relentless, the organization has to publicly and honestly relate the facts, present a plan for fixing the problem, and counterattack with frequent public discussions on the good work of the institution and its exciting future programming plans.

In any form of crisis, board and staff leadership must take control, calm all constituents, and present a clear and comprehensive plan. Press activities must be coordinated through one person; if numerous staff and board members begin feeding information to the press, the organization will not look professional or in control.

International Boards

42 OUR ORGANIZATION IS NOT IN THE UNITED STATES, DOES THAT MAKE A DIFFERENCE?

American boards tend to function very differently from boards in most other countries. This is a direct result of differences in funding sources for arts organizations across the globe. In the United States, where government funding usually comprises a small portion of total funding for an arts organization, boards are expected to take a very active role in developing resources. While this expectation is not always met, there is a common understanding that the board is meant to be helpful giving and getting funds.

In other countries, where the government is the largest donor, often by a large margin, boards are not expected to get or even give funds. Board members in these countries are considered overseers, typically having largely ceremonial roles. In many countries, the board is appointed by the government to oversee the public funds invested in the organization. Unfortunately, most governments around the world are now reducing their level of arts funding, and arts organizations are desperately trying to raise private funds to replace lost government funding. But they are doing so without the help of their boards — clearly a difficult, if not impossible, task.

This also means that non-governmental organizations (NGOs) in these countries, often smaller and younger groups that do not receive government funding, operate in an environment where their boards are not expected to help with resource development. The staff members of these groups spend a great deal of time and effort looking for contributed funds, frequently from overseas foundations and governments. They must increasingly compete for private contributions with government-funded organizations that are now losing a portion of that funding.

I have taught and consulted throughout the world, and the lack of board involvement in revenue generation is the biggest problem inter-

national arts organizations face as they try to develop private sources of funding, particularly from individual donors. And individual donors do represent the largest *potential* pool of resources available to not-for-profit organizations. When consulting for a major southern-hemisphere theater company, I asked a very wealthy, passionate member of its board why she did not contribute to the company. She replied, "I do contribute; I come to board meetings." This sentiment is not uncommon, but also not very helpful. It must change if global arts organizations are going to thrive, as governments find they must allocate their resources elsewhere.

When I joined London's Royal Opera House in 1998, the board had just seven members, only one of whom was a major donor. As the funding of arts organizations in the United Kingdom has changed, with private contributions becoming increasingly important, the board has changed, as well. Today, there are seventeen members of the Opera House board, who are now responsible for finding resources.

This shift in board responsibilities is going to sweep the world, just as the need to develop private resources is sweeping the world. Engaged, helpful boards are clearly not limited to the United States. The board of the Al-Kasaba Theatre in Ramallah, Palestine, is certainly an involved and concerned group. On my visits there, I meet with the members of this board, all of whom feel particularly responsible for the organization. What differentiate the board of Al-Kasaba from the best boards in the United States are primarily the fundraising experience and the expectation that board members have an obligation to donate their own money. As the theater continues to build and develop, the people asked to serve on the board will probably change. Like younger organizations in the United States, the board members of Al-Kasaba Theatre are mostly friends of the founder, in this case George Ibrahim.

Like many arts organizations in less developed countries, Al-Kasaba has relied on funds from outside the nation. This will not be sustainable in the future. As is true in so many countries, if private contributions are going to grow in a consistent manner, a larger percentage of fundraising revenue will have to come from inside the country. This will force boards to change in Ramallah and elsewhere.

It is essential to understand that this change in international boards, which can be expected throughout the world over the next ten years, is not due to an endorsement of the American system of arts funding or board structure. Rather, it is the direct result of the reduction in govern-

ment funding, which is forcing arts organizations to find private revenue sources.

Not only will board membership have to change, but the focus of marketing efforts will also have to change. Institutional marketing will have to be featured in the plans of most arts organizations if they are going to attract new board members and new sources of contributions. This will be a substantial change, since institutional marketing in most countries has happened by accident rather than by design.

The necessity for these changes will be further exacerbated by the current shift in funding from earned to contributed income. If the level of contributed income from all sources does not grow, the arts will become increasingly the province of the elite. But building the level of contributed income will require more than changing board membership. It will also require creating a culture of giving, and nurturing the belief that it is not *solely* the government's job to support the arts. This can only be accomplished when numerous arts organizations in a given location are able to develop the benefits for donors that entice them to contribute on an ongoing basis.

Arts Organizations of color

43 OUR ORGANIZATION IS AN INSTITUTION OF COLOR, DOES THAT MAKE A DIFFERENCE?

Although arts organizations of color are similar to white organizations in most respects, there is one important difference: the sources of contributed revenue. While white organizations typically receive sixty percent or more of their funding from individual donors, arts organizations of color usually rely heavily on institutional gifts, especially from government agencies and foundations. This is problematic for several reasons: there is a limited number of government agencies and foundations that will fund a given arts organization. When the pool of institutional donors is so small, the organization is placed in jeopardy; if any one agency disappears or substantially reduces its gift, the organization is adversely affected in dramatic fashion. And these institutional donors frequently do reduce their gifts.

Most foundations do not support an organization indefinitely, and since there are very few professionally managed foundations formed each year, the organization does not have a growing pool of prospects. This places the organization at risk. And both government agencies and foundations are very cyclical in their giving. When the economy is in recession, foundations tend to give less since their investment portfolios are worth less. And government agencies give less since tax revenue declines. Government agencies also reduce funding for political reasons; very few increase their giving substantially. Moreover, these institutional funders typically have a cap on the size of their gifts. So if the number of donors is limited, and the size of the gifts is limited, then the size of the organization is also going to be limited—and arts organizations of color rarely grow very large. What is missing from the fundraising portfolios of most arts organizations of color are individual donations. This is troubling

since arts organizations of color are missing out on the largest funding source. The average arts organization of color gets less than ten percent of its donations from individuals.

This disparity results from a lower level of contribution from the home communities of these organizations and from boards that are constituted differently. While the communities served by arts organizations of color are usually very generous and philanthropic, the beneficiaries of their giving tend to be religious, educational, or health-related organizations. While progress has been made over the past decade, there is still a relatively small amount of arts-related philanthropy in these communities. But there would be much more, if more community members were approached. Many arts organizations of color believe they cannot raise money in their home communities, because of their perception that their constituents have other needs and will not give to an arts organization. But that is rarely the case — board members and staff simply have to ask.

More problematic is that arts organizations of color often have many community leaders, not-for-profit executives, and politicians on their boards. These individuals can be passionate supporters but are generally not very involved in fundraising for the arts. Just as their white counterparts must evaluate their board members to determine if they are the right people to meet the current needs, so too must arts organizations of color evaluate their boards.

Many arts organizations of color serve audiences whose members can afford less for tickets. So these organizations tend to have lower levels of earned income and must rely even more on contributed income than their white counterparts. This makes board restructuring even a greater priority if the organization is going to grow to a stable size.

Many arts organizations of color have done a brilliant job of building board strength and supplementing fundraising from institutional gifts with private donations. But this effort must continue in a disciplined fashion so that the organizations can continue to have a healthier, more diversified donor base.

subsidiary Boards

44 SHOULD WE HAVE A SUBSIDIARY BOARD? A VOLUNTEER GROUP?

Numerous arts organizations have subsidiary boards, which are groups of individuals who provide a service to the organization, but do not have fiduciary responsibilities. But the nature of these boards varies substantially from organization to organization.

The most common type of subsidiary board is an advisory board. For many organizations, an advisory board is a collection of artists who endorse the work of the organization — usually friends of the artistic director — but who really have little to do with the organization. These boards are non-functioning groups, whose members' names often serve as an imprimatur for the organization. There is no harm in having these groups, but there is truly little value. Probably no one is fooled into thinking that these artists actually participate in the artistic life of the organization. The only time these names can actually be harmful is when they are placed on the gala invitation, with the implication that these great artists will be in attendance at the event. When none of them shows up, the paying guests can be disappointed.

Other institutions have advisory boards composed of former trustees or donors who are not on their board. In many cases, board members whose terms have expired are placed on these advisory boards, which are really a parking lot for people who do not want to serve on the main board, or more often, are not wanted on the main board.

Because these boards usually never meet, and their members do nothing substantial for the organization, these boards tend to do more harm than good. Invariably, one or several members of these boards are frustrated that they have no role with the organization. They were asked to serve on a "board," and yet they have no real function. This breeds discontent that is not helpful to the organization. While these boards are created to satisfy certain individuals by giving them an "official" position in the

organization, these groups rarely accomplish this goal, and most advisory board members are not truly happy.

While these auxiliary boards are usually not useful, there are many examples of helpful, involved subsidiary boards. They do not have fiduciary responsibility for the organization, but are characterized by a high degree of productivity, facilitated by an involved staff. Some auxiliary boards, for example, run special events. When I was general manager at the Kansas City Ballet, its Guild (or women's committee) produced an annual gala, freeing up the rather small staff to do other work. The Guild saw to every element of the event, from designing the invitations to selling tickets, from planning the décor to organizing the menu. It was a full-year project, and they did it splendidly. The Kennedy Center has a community advisory board that includes members from the diverse communities of Washington, D.C. This is not a fundraising board; its function is to advise the staff on ways to penetrate their home communities: how to market to them, what repertory would speak to them, and how to include them in outreach and other events.

Many larger organizations also have subsidiary boards made up of groups of donors. The Royal Opera House and several other large European arts organizations have American boards, charged with raising funds in the United States. These visual and performing arts groups know that it is easier to raise funds in the United States than in their own countries; the challenge is to identify Americans who are interested enough in the work of an overseas organization to contribute funds and to solicit their friends.

Conversely, the Kennedy Center has an international board — comprised of people from other countries and the United States — that supports the Center's international programming. It is unusual for an American arts organization to attract donors from other countries, and it only happens when the programming excites and entices foreign donors. But when an organization can attract contributors from other countries, and when these donors involve their friends and associates, the field of potential major sponsors grows immeasurably. The Kennedy Center also has a corporate board composed of corporate executives who support the Center's work. Each member of this board commits to contributing a specified sum over a period of years and also promises to solicit other corporate leaders to join this board. The group never meets formally and is clearly not a decision-making body, but rather a group of patrons with similar interests.

Many arts organizations are simply too small to create productive auxiliary boards. To make a board or volunteer group useful requires heavy staff involvement. Without staff to provide information, to coordinate the activities of the auxiliary board, and to keep its members involved in the activities of the organization, these groups almost always become inactive. Smaller organizations should not attempt to build auxiliary boards. Instead, they should spend their time building strong relationships with members of their main boards; diluting this effort is not advisable.

Yet even small arts organizations can sometimes benefit from a carefully constructed volunteer program. Volunteers can be extremely helpful to an arts organization, performing many functions, including helping with office work, serving as quasi-staff, manning information desks, or working in gift shops. But volunteers require management, as much as staff members do. Many arts organizations make the mistake of bringing in volunteers and then not managing them; they expect the volunteers to work on their own. Happy, productive volunteers require training, oversight, and motivation. But when volunteers are well managed, they can be incredibly productive, and they can also be great ambassadors in the community. When volunteers are not managed, they can become unhappy and unproductive. Arts organizations should only build volunteer programs when they believe they have the personnel capable of managing the volunteers well.

Board and Programming

45 AREN'T ALL ARTISTS SPENDTHRIFTS?

One of the notions commonly held by many people, including board members, is that artistic directors — in fact all artists — are spendthrifts: they do not care at all about what they spend, how much they waste, or if they are staying within the specified budget. Taken to its extreme, this line of reasoning suggests that artists do not care about the fiscal health of the organization and are completely selfish in their desire to express themselves at the expense of others.

This mistaken notion has been reinforced in various forms of popular entertainment depicting artistic directors who demand all kinds of frivolous things, while helpless assistants watch. This view of artists arises from a lack of appreciation for the creative process. Making a play, ballet, or opera requires trial and error. Unlike solving a mathematics problem or balancing an equation, there is no correct answer. So artists are constantly experimenting and discarding failed experiments. There *is* a certain amount of "waste" when making important art.

Arts organizations, desperate to fill income gaps, abhor waste. Therefore, the concept that the artistic director might be wasting money, when the rest of the organization is struggling to make do, can create a great deal of bad feeling on the part of the board and executive staff. For many board members, the existence of an income gap at all is evidence that somebody is spending unwisely, because in their own businesses there are no income gaps, only profit. Many people outside of the not-for-profit field truly believe that if not-for-profit organizations were better run, there would be a profit and no need for fundraising.

Boards and administrative staff feel that if the artistic directors would only rein in their spending and waste, a substantial portion of their financial problems would be solved. Since most board members come from

the for-profit sector, and the nature of the products they produce is so different from art, they cannot understand the trial-and-error approach to arts making.

It is true that some arts organizations could save on costume or set expenses, or on money to load a production into the theater. But most artistic directors are very frugal, trying to make the most art out of the least amount of money available. The major sources of expenditure for most arts organizations are related to salaries, and few arts organizations, anywhere, are overstaffed.

While the arts require some trial and error — which means that not every expenditure is ultimately productive — the arts industry is actually one of the most efficient in our economy. Much art is created, despite very small budgets. Plays mounted by not-for-profit organizations cost substantially less than the same productions presented on Broadway. For example, the Kennedy Center's production of *Ragtime* cost only half as much as the production did when it transferred to Broadway.

Not-for-profit arts organizations are also incredibly efficient when it comes to marketing budgets. There is a long list of world-renowned visual and performing arts organizations that have achieved international fame while spending only a small fraction of the marketing money spent by large corporations. The lack of available resources has forced arts organizations to be extremely careful with money and to become very creative with the way money is or is not spent.

Young arts organizations tend to be so parsimonious, and to enlist so many people who are generous with time and materials, that they have a false notion of how much it actually costs to mount a performance. This only becomes clearer as the organization matures, and people are not willing to donate their time and materials on an ongoing basis. When they recognize the true cost of producing, many young organizations have to cease operating entirely.

Yet the belief that arts leaders are wastrels is still prevalent. This is a dangerous concept for three reasons: first, it encourages the board and executive staff to spend time looking for waste when they should be looking for money. If the leaders of the organization are convinced there is waste, they will work hard to eliminate it since cutting budgets is always perceived as an easier solution than finding money. But this effort is far less productive than finding new resources, and in the long term can lead to the serious weakening of the artistic product and hence the organization.

Second, being overly concerned about waste creates a wedge between the organization and the artistic leaders — the very people the board and executive staff are meant to serve.

Finally, this line of thinking makes it more difficult to build a broad base of support for an organization. Who will want to support an artistic endeavor, if the board members believe the artistic leader is wasting money?

It is important for board members to explore where there might be waste, but it is far more important for them to recognize that the nature of the creative process necessitates that time and energy be devoted to finding resources for an organization that needs money to produce important and exciting art.

46 WHAT IS THE BOARD'S ROLE IN ARTISTIC PLANNING?

If the art of an organization is the foundation of its health, then the artistic planning process is crucial. It would be logical to assume that something so critical must be of interest to the board. There are substantially differing points of view about the board's role in planning a season, but the central role of the board vis-à-vis artistic initiative is hiring and compensating the artistic director. (In those few organizations where the artistic director reports to the executive director, the board members' evaluation of these executives must include their perspectives on the art produced during these executives' tenure.) The selection of an artistic director is so serious because this is the board members' chance to express their artistic views.

But normally, once artistic directors are selected, boards must be willing to allow them to do their work; there are very few board members equipped to develop an annual season. Even though board members will have views about works they prefer and casting they think is optimal, the numerous factors that go into planning a season elude most amateurs. Artistic directors are not just considering this year's repertory; they are also thinking years in advance. They are evaluating the availability of talent, the developmental needs of company members, the technical requirements, and the budget. The best artistic directors are also thinking of the

relationships between works within a given season: how do they combine or contrast to teach or entertain or inspire the audience?

When boards take over the programming responsibility, the seasons inevitably suffer; this is a job for professionals who have both short-term and long-term artistic vision and comprehensive knowledge of the way a season is mounted.

This is not to say that individual board members do not have the right to express their opinions to the artistic leader. The artistic planning process benefits from many differing views. But after all of the discussion, individual board members must accept that their wishes may not have been adopted in the final plan. If these members become vindictive, problems can emerge for the whole organization. And if it becomes "acceptable" for groups of board members to openly discuss the perceived problems in programming, the entire culture of the organization is undermined. The staff and board leadership must intervene to ensure that irreparable harm is not done. Of course, when there is a longstanding consensus that the work is not good enough, the artistic director must be replaced. The health of the organization begins and ends with the quality of the art.

While the board should not approve each individual production, the board should approve a long-term artistic plan as part of the strategic planning process, and must approve the in-depth plans for the next season as part of the budgeting process. This means that the board must learn about the productions, and so it is important for the artistic director to explain the programming plan. Why was each production selected? Who is the target audience? How will it further the artistic reputation of the organization? How will it help achieve the mission of the organization? The art must be interesting to numerous constituencies with differing tastes and interests — the audience, the press, and the donors. The board has an obligation to review the season to ensure there will be enough interest to support the financial projections in the budget. This is one important reason for planning artistic and educational projects a number of years in advance; if the board only has a few days or weeks to evaluate a season, it does not have adequate time to do due diligence.

When evaluating the artistic plan, board members must remember that the goal of the best arts organizations is to lead the audience, not follow it. The greatest art projects should be surprising to the audience; rarely does work selected to please an audience break new ground or make an im-

pression for the organization. Many board members are inclined to want to produce the tried and true, because it is safer, because ticket sales revenue can be predicted more easily, and because they understand this art. But if the art is merely competent and not exciting, the long-term visibility and fundraising potential of the organization are affected.

The tension between an artistic director hoping to do something new and a board wanting to be conservative can be healthy, if it is managed well. It is up to the staff and board leadership to ensure that these discussions are helpful and productive, rather than angry and insulting.

Ironically, both sides in this debate have the same long-term goals; organizations that consistently produce interesting, exciting, surprising art end up with the visibility and the earned and contributed income needed for financial stability. It is the fear of short-term risk-taking that creates tension in so many arts organizations.

47 HOW MANY YEARS OUT SHOULD WE BE PLANNING OUR ART?

Most organizations plan their artistic programs one or two years in advance. Many, especially young or small organizations, plan their art just a few months in advance. (The major exceptions are large opera companies which need to engage world-class singers and conductors many years in advance.) Some organizations suggest that they have short planning horizons, because they are uncertain what level of resources will be available in the future. Others are afraid to commit to programming so far in advance because they want to take advantage of opportunities that might present themselves at short notice, or produce contemporary art that cannot be anticipated in advance. Ironically, most arts organizations have far longer planning horizons for their marketing and fundraising campaigns than for their arts programs.

But maintaining a short planning calendar has true costs, as well. Major artistic programs should be planned four or five years in advance. One is far more likely to find the resources required for great art if it is planned that far ahead. Even arts organizations that produce contemporary art can plan for the artists to be commissioned or plan the themes of future projects. This does not mean that organizations should not be flexible,

however. Wonderful projects may emerge at the last moment, and some planned projects may not come to fruition.

But there are true advantages to planning art well in advance. First and foremost, a longer planning horizon positively affects the quality of the art. The more time there is to plan a project, the more time there is to study the field, determine the best way to pursue the project, and ensure that all elements are thought through and aligned. The likelihood of engaging the artists best suited for the piece is also optimized. This is particularly true if the goal is to engage artists who are well known and in demand.

Planning in advance also allows arts organizations to create the complicated, reputation-changing projects that a short time frame does not permit. Large festivals, world-premiere commissioned works, and projects featuring artists of great reputation are important milestones for arts organizations and play a central role in their institutional marketing efforts. The resources required for these large projects cannot typically be raised in the usual time frame; new donors have to be identified and cultivated, and this takes time. But when these activities are approached with vigor and discipline, substantially larger projects than the norm for the organization can be developed and paid for. The resulting increase in visibility and reputation helps attract new donors and new artists for future projects. This is why large projects are so central to the development of arts organizations.

In 2009, for example, the Kennedy Center mounted a landmark festival of Arab art. It took five years to conceive of the festival, identify the best artists, write contracts, obtain visas, and raise the substantial funds required; if there had been far less time to plan this project, it would not have been successful. Projects that are rushed usually look rushed.

Having a multi-year list of planned projects can help with normal fundraising, as well. Many arts organizations try to convince a donor to support a project that is planned for the coming months. They are so concerned they will not have the required resources that they present no options to the potential sponsor. But not every potential donor will be interested in that particular project. The prospect may not give at all or may give only a token amount to a project of little interest. It is far more effective to listen to donors and determine *their* giving interests. They can then pick, from the four- or five-year "menu," the project that is most likely to interest them. This increases substantially the odds of receiving a gift at all and certainly of receiving a large gift.

Programming well in advance also helps the marketing effort. It gives the public-relations staff time to build interest among the members of the press, and to determine which journalists are most interested in the project. The marketing staff also has time to evaluate the project, to suggest the optimal ways to build audience interest, and to determine its role in the institutional marketing program. For less accessible projects, more time is needed to educate the audience about the work and to generate interest and excitement. The Kennedy Center Arab Festival sold ninety-two percent of the available seats because substantial public relations, marketing, and education programs had been implemented well in advance of the project.

Programming far in advance allows the organization to ensure that each year is affordable. A *pro forma* budget can easily be created for each planned season to determine whether the suggested programming for any given year must be changed to make the budget more realistic.

Touring organizations that plan ahead also have a far easier time convincing presenters to engage them. Presenters want to know the repertory that the companies will present, especially if there is an exciting new work. Since many presenters work two or three years in advance, it is helpful to them to know the new repertory that is planned for the year of the tour.

Finally, it is clear that the public really evaluates our missions not by the statements in our annual reports, but by the work we do. After laying out a five-year programming plan, it can be determined whether the mission is truly being expressed by this programming; often it becomes evident that a major part of the mission has been left out of the planning. This means that either the mission must be reevaluated or the programming is deficient.

Despite these benefits, for many arts organizations planning this far in advance is scary. They are concerned that they are committing to work before they are ready. They fear that they will create projects that are ultimately unaffordable. However, developing a multi-year artistic planning calendar has proven to help focus the entire organization and make it far more likely that the dreams of the artists will be realized. An involved board does their artists and administrators a favor by encouraging them to create such a long-term plan.

48 SHOULD WE FORM JOINT VENTURES?

Well-designed, carefully contracted joint ventures can play a major strategic role in elevating the quality and scope of artistic and educational offerings of most arts organizations. Joint ventures permit organizations to mount larger projects, to consider projects that require skills or talents they do not possess, to extend their marketing and fundraising reach, and to design the mega-projects that will alter the organizations' legacies.

There are many kinds of joint ventures that arts organizations can consider, as they aim to enhance the quality of their programming. The simplest type involves two or more similar organizations sharing a project. For years, opera companies have shared productions. The sets and costumes for an opera can be very expensive, and since opera companies typically do only a few performances of any one production in a season, it makes sense to share sets and costumes. This kind of partnering allows opera companies to save money and produce more new productions in a given year. Even the world's largest opera companies may share, among three or more companies, the development of new productions, including directorial concept and the associated sets and costumes.

But many of the most successful joint ventures are formed between arts organizations of differing genres. The Hubbard Street Dance Company, a wonderful modern-dance company in Chicago, for example, has formed a joint venture with the Chicago Symphony Orchestra. The orchestra devotes one week of programming each season to a joint program with the dance company. This allows the orchestra to diversify its programming — a goal of many symphonies. It also permits Hubbard Street to build its prestige by performing with one of the world's great orchestras and to expand performing opportunities in its home city — a goal of most modern dance companies.

There are also examples of arts organizations collaborating with institutions that are not specifically arts related. In the early 1990s, the Alvin Ailey American Dance Theater established a collaboration with Fordham University, located just across the street from the Ailey building. Fordham's students could fulfill their physical education requirements by taking classes at the Ailey School, and the Ailey dancers could take academic classes at Fordham. Both organizations benefited in other ways, as well:

Fordham could use the association with Ailey in its marketing materials, and the Ailey organization markedly increased its own school tuition revenue.

Each of these types of joint ventures has the additional benefit of exposing the work of one venture partner to the audiences and donors of the other. When organizations work together, they can build their constituencies by impressing the "families" of the other venture partner.

It is particularly interesting when smaller, less well-known organizations collaborate with larger or more prestigious organizations. The imprimatur of the larger company can impress existing family members of the smaller group and motivate the press to pay more attention to the activities of the smaller company. The donor base and audience of the larger organization may also become interested in supporting the smaller one.

Joint ventures are particularly important when an organization needs to build its reputation for excellence and innovation, yet cannot afford dynamic programming on its own. When I arrived at American Ballet Theatre, it was virtually bankrupt. Programming had not changed very substantially for several seasons, and it was obvious that it needed an important new project to excite the donors, audience, and press. We developed a joint venture with San Francisco Ballet to create a new work based on Shakespeare's *Othello*. This project required commissioning a new score, creating new choreography, and designing and building new sets and costumes. *Othello* was the largest project in the history of ABT. It was a seemingly foolhardy thing to do when we were in such bad financial shape; yet this project allowed us to announce an exciting new venture, exactly at the time people thought we were going bankrupt and were afraid to contribute to the company. Two years later, ABT had eliminated its entire deficit and added a second season in New York City.

Creating a successful joint venture requires time, a clear concept, and a strong contract. Too often, joint ventures are agreed to without proper consideration. In that case, one or more of the partners invariably feels let down at best, and cheated at worst. It is essential that both partners benefit from the partnership; otherwise, the venture will not last. Frequently, one venture partner comes to believe that the other partner is receiving a disproportionate share of the visibility. Smaller organizations, especially, have reason to fear that they will not be visible compared to their larger partner. For this reason, time must be taken to ensure that the contract

specifies how each partner will be credited, and how press attention will be shared. The contract must also account for other eventualities, including cost overruns, time delays, and financial problems that might preclude one partner from fulfilling its obligations.

The board can play an important role in helping to form joint ventures by introducing the staff to potential partners. Board members must also evaluate joint ventures to make sure their organization is going to benefit from the project, and that the contract is written in such a way as to protect their organization. Smaller groups, without access to sophisticated legal help, must especially rely on their boards to assess important joint venture contracts.

49 SHOULD WE BUILD A TOURING PROGRAM?

For many arts organizations, touring is an integral part of their strategies. For some, it is a central element of their mission statements. These organizations have a goal of educating, entertaining, and inspiring people beyond their home communities. These organizations must develop a touring program if they are to fulfill their missions.

Other organizations believe that establishing a reputation outside their own community is essential to building the level of support they need at home. When people from other communities respond positively to the work of those organizations, and the "foreign" press writes positive reviews, donors and audience members from the home communities take notice. These organizations tour to enhance visibility and reputation.

Still others tour in an effort to expand the scope of their fundraising campaigns. These organizations find they can raise money successfully in other communities if they *regularly* serve those communities. The consistency of touring to these outside areas is crucial; only when an organization establishes relationships with audience members and donors is fundraising likely to be successful. It is not a coincidence that some international performing groups, like the Mariinsky (Kirov) Ballet and the Royal Shakespeare Company, regularly perform in the United States since they maintain fundraising arms here.

Finally, there are the organizations that need to tour because their home seasons are not long enough to maintain the quality of their work.

Most modern-dance companies, for example, need to tour since the number of weeks they can perform at home is very limited.

Many organizations tour for a combination of these reasons. They create more performing opportunities, achieve their missions, expand their fundraising scope, and build their reputations for excellence.

Unfortunately, there are just as many good reasons *not* to tour. Touring is expensive and rarely breaks even, especially for larger groups like orchestras and opera companies. Touring takes the focus of the organization away from its home market, where the majority of fundraising support and earned-income revenue are typically raised. Touring also rarely builds reputation at home, since most people are unaware that the company has travelled at all. And unless an organization establishes a high degree of visibility in the touring city, it is extremely hard to raise any substantial money there.

This is not to say that a well-planned touring operation cannot ultimately be profitable. It can be, if it is planned well. The first step is for the board and staff to commit forcefully to touring. It is unproductive to tour once every five years, or to tour for a year or two and then stop. The entire organization has to decide to devote scarce resources of money and time to touring.

Then a touring strategy must be developed that addresses where the company will tour, and how frequently it will visit each tour city. Too often, touring decisions are left to the tour presenter. A tour presenter is generally another not-for-profit organization, frequently a university, that pays a fee to the company to perform in its community. The presenter takes all financial risk and is responsible for booking the theater, engaging the production crew, and doing the marketing. The presenter also retains all ticket-sales revenue. If an arts organization simply accepts the invitation of any presenter that comes along, there is likely to be no real benefit to touring; certainly the opportunity to expand fundraising is minimized if there is rarely a return visit to a given city. And a reputation is only built at home if the tour takes the company to prestigious cities, and people at home are made aware of the tour.

Once the key cities are identified, the staff or tour agent (a person who represents the organization in its negotiations with tour presenters) must work to interest a local presenter in each target city to engage the company. This is a sales job that can be achieved with press kits, videos, invitations to see the company perform, and discussions.

It is vital that boards understand the financial agreements between the tour agent and the organization, and the presenter and the organization. The world is full of arts organizations that got into serious financial trouble from bad touring agreements. The safest tours are those that guarantee the company a fee for performing, which covers the cost of the artists, transportation, and accommodations. When no local presenter is interested in taking the financial risk, the company can choose to self-produce. This means the company takes all financial risk, hires a theater, manages the marketing, and mounts the production. The company's "fee" is the ticket revenue earned at the box office. This is a highly risky strategy, since the company probably does not have a great deal of knowledge about selling tickets in the tour city, has no built-in subscription base, and has no relationship with the local press. And all of that can be very expensive to learn. When I got to American Ballet Theatre in 1995, the company was still paying off the loss of a self-presented tour to London many years before. Sometimes the tour deal is a hybrid: a presenter organizes the visit, but the company's fee is determined by the success at the box office.

Touring can be an important element of the artistic, marketing, and fundraising strategies, but if mishandled, can lead to financial disaster. The board must play a role in developing the tour strategy and must understand the financial risks and rewards.

50 DO WE NEED AN EDUCATION PROGRAM?

No arts organization has to mount an education program. The elements of the mission of any not-for-profit are the sole province of the organization itself; no one has the right to set goals for another organization. This is a primary benefit of working for a not-for-profit organization. Arts managers do not earn as much as they would in the corporate sector, but they go to work each day knowing they are pursuing a mission that matters to them and to the broader world.

But fortunately, many arts organizations do include education in their mission statements. Since so many public schools in the United States and across the globe do not include arts education in their curricula, we now have a generation of young people who have not developed the habit

of arts engagement. This is a serious issue, since we rely on this generation to be the art creators, audience, donors, volunteers, and board members of the future.

Arts organizations have worked aggressively to fill the breach left by our public schools by offering an array of arts education programs. Some arts groups focus on delivering arts programs to school students, others to school teachers, and still others to families and children outside of schools. Arts education trains our children to be productive members of the work force. Not only does involvement in the arts improve test scores in basic subjects like math and reading, but it also helps children develop the problem-solving skills they need to be successful in our new creative economy.

Arts-*in*-education programs, a subset of arts education programs, use the arts to teach academic subjects. A physics teacher, for example, may use music to help teach the physics of sound. This has been a popular approach to arts education in the last fifteen years. However, many artists object to this being the only approach to arts education. They understand the value of the arts for their own sake and believe the arts should be a separate part of the curriculum.

Many arts organizations offer arts education programs to expose children to the beauty of the arts and to the joy of arts participation. Several arts organizations also offer training for performers or visual artists at the introductory through advanced levels; these more specific programs typically have fewer participants than the arts exposure programs. A smaller number of arts organizations offer arts education for adults; this can be introductory lectures, classes in performing techniques, or advanced programs focusing on serious intellectual pursuits.

All of these arts education programs for various levels are offered through an array of delivery techniques. One traditional program — professional performances geared to students and perhaps complemented by pre-performance classroom materials or post-performance activities or readings — is still the most common arts education offering. But there is an increasing use of internet or satellite technology to offer arts education to larger numbers of students. Use of these technologies has the corollary benefit of creating a permanent archive of arts education modules that can be used at any time, in any corner of the world.

The challenge with all arts education programs offered by arts organizations is that they are not woven into a cohesive, comprehensive fabric.

Stand-alone arts programs are not broad or pervasive enough to reach every student. For most school children, arts education is very episodic. In many schools, it is left to the individual teachers to decide whether children in their classes will have the benefit of arts offerings from local institutions. If a third grade teacher likes the arts, the students will get many arts experiences. If the fourth grade teacher does not care about the arts, the students may get no exposure at all. No other subject is taught with such carelessness and inconsistency. Children most in need of the arts routinely come from families that lose a parent, a job, or a home. This theme of loss pervades the lives of these children, and when we give them a great arts experience, and then take it away, it exacerbates this sense of deprivation.

A key for truly effective arts education programming is not simply to count the number of students enrolled, but to ensure that there is an integrated approach allowing children to build their arts knowledge systematically. Board members must inquire about the true impact of the arts education programming of their organization. How do the programs intersect with others offered in the community? How do children get a comprehensive arts education? If we only count the number of children in our programs, if we only take heart in their smiling reactions to our student performances, we are not necessarily fulfilling our missions.

Epilogue

The past year has afforded me the opportunity to travel across the nation and the globe. I have met more arts managers and board members in this period than I have in the rest of my entire career. I have heard inspirational stories, sad stories, frustrating stories, and crazy stories. I have learned far more than I have taught.

On every stop of my fifty-state, sixty-nine-city Arts in Crisis Tour — an attempt to help arts organizations cope with the current economic crisis — the issues most discussed were those relating to arts boards. My thinking has clearly been affected by what I heard. One board chair told me that the only thing that was important to his organization's success was its board. To him, programming, staff, and marketing were of minor consequence. Other board members told me that they were miserable. I heard staff members criticize their boards, and board members criticize their staffs. It seems the only clear thing about boards and staffs is the lack of clarity.

Perhaps the most liberating thing I said on my tour was that it was appropriate to ask unproductive board members to resign. This was a novel idea to many. And in the space of an hour-and-a-half presentation, board members and staff members took a journey from disbelief, to consideration, to excitement, to relief, as I discussed the topic. (I am sure many are still in the "disbelief" stage.) Writing this book and going on the tour was a powerful double whammy for me. I learned many things, but ten points stand out for me:

1. *The mission is crucial.* It measures success and should guide all decision-making. I knew this before the tour, but I learned that most boards don't really buy into the missions of their organizations. They may "like" ballet, but they are not willing to accept that producing good ballet is more important to the organization than making money, or at least breaking even. This is perhaps the most crucial issue not-for-profit organizations must address. If the board of an arts organization does not truly buy into the mission,

it will be virtually impossible for the staff to make consistent artistic progress.

2. *Organizations experience life cycles*, and boards should reflect the changes in the development of the organization. Well-governed arts organizations have boards that evaluate whether the membership of the board is appropriate for the place of the organization on the life cycle. Board membership *should* change over time. Few people can ably serve an organization throughout its entire life cycle. The people who help start an organization are not often the same people who should govern the mature organization. A strong, sophisticated board will consistently monitor its own membership and make changes as necessary. But too often this is not the case, and a wrenching period of discontinuity is required when an ineffective board is discovered to be the cause of serious problems.

3. *Unproductive board members hurt organizations* more than most people realize. Board members who do not meet their obligations deflate the remainder of the board. They discourage productive board members from giving as generously as they might and from introducing their friends and associates to the organization. When a group of board members are not meeting their obligations, it causes dissent on the board. The board begins to focus on the inequity in participation, rather than on how it can support the mission of the organization. At its worst, this situation can substantially hamper the organization's progress.

4. *There is real expertise needed to run an arts organization.* Board members must respect the expertise of the staff, but they must also evaluate objectively whether the staff possesses the requisite skills. Arts management is not a hobby. The best arts managers have knowledge and experience and an entrepreneurial bent. Very few board members, despite their own business acumen, have the knowledge to second-guess the best arts managers. The great artistic directors have both the vision to lead the audience and the creativity to produce surprising and excellent seasons. While most board members have their own levels of taste and artistic knowledge, few of them could produce a truly wonderful season.

5. *Boards need to spend more time in their communities* and less time in meetings. Most board members allocate a certain number of hours

a month to the organizations they serve. This may not be an explicit decision, but rather an internal clock that suggests when too much time is being spent with one particular organization. Unfortunately, too many board members use most, if not all, of this allocation in board meetings, committee meetings, and informal discussions with other board members or staff. Board members must begin to reallocate their time to spend more of it soliciting resources and building bridges with community leaders, and spend less time on meetings. Otherwise, the board will not be as potent as it needs to be.

6. *Board members need to understand the budget* before they approve it. I have rarely seen a board that truly understands the budget they are required to approve. Often, the budget is approved if it balances, and if total expenses grow a "reasonable" percentage over the prior year. Approving the budget is one of the five cardinal responsibilities of a board member. At least a substantial number of board members must understand the details before the budget is approved, to ensure that it makes sense, and that the operating strategies support the revenue targets set in the budget.

7. *A well-functioning arts organization does not need an endowment.* Although it is a nice thing to have, an endowment is not a panacea. Too many people assume that an endowment is *the* requirement for success in the arts. It is understandable for board members to look for ways to reduce risk, especially fundraising risk. But since arts organizations almost always grow to the point where they are uncomfortable, even an organization with a good-sized endowment fund will usually build expenses to a level demanding substantial additional fundraising. And most organizations, with no endowments, do not have a strong enough annual effort to afford to divert attention to endowment funding. When endowment campaigns are pursued prematurely, the entire organization can suffer, as programming is cut because annual fundraising is reduced.

8. *Planning requires planning.* A well-planned process makes strategic planning more efficient and effective. Most boards believe that planning is "good for them," but then pursue the development of plans without adequately thinking through the process. Too many strategic plans also omit long-term artistic and educational

program planning — prerequisites for strong marketing and fundraising strategies. A good planning process reduces the time it takes to write the plan and ensures that a more thoughtful and coordinated plan is created. Otherwise, planning backlash, the feeling that less planning is better than more, is likely to develop.

9. *Boards always want to reduce the pressure of fundraising,* but ticket-price increases are not a responsible substitute for getting donations. Many organizations have continued to raise prices to balance the budget, but as a result have disenfranchised large segments of the population and inadvertently fostered the belief that the arts are irrelevant or elite. We must acknowledge the high level of inflation in the arts and recognize that if we are to achieve our goal of serving a broad spectrum of the population, we have to continue to raise more money.

10. *Boards are not wholly responsible for fundraising success,* but they must make sure the organization functions in ways that support fundraising. There is a commonly held belief that boards are entirely responsible for fundraising. This is incorrect conventional "wisdom." It is up to staff leadership to guide the fundraising effort and *motivate* board members to participate in this effort. But the board must work with staff leadership, both artistic and administrative, to make sure that the organization produces the art and mounts the marketing campaigns required to achieve fundraising success.

It is not easy to be a good board member. It is harder still to assemble a group of volunteers to work together with paid staff to further the mission of a not-for-profit arts organization. But when it works, and the organization consistently produces interesting art and achieves fiscal stability while doing so, the joy of being part of something meaningful and sustainable is difficult to match.

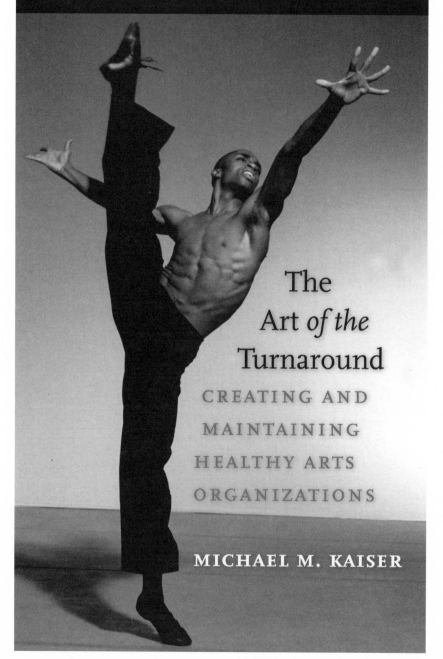

Also from Michael Kaiser

The
Art *of the*
Turnaround

CREATING AND
MAINTAINING
HEALTHY ARTS
ORGANIZATIONS

MICHAEL M. KAISER

The Art of the Turnaround

Creating and Maintaining Healthy Arts Organizations

MICHAEL M. KAISER

**PRACTICAL ADVICE (SUPPORTED BY
EXTENSIVE CASE STUDIES) FOR FIXING
TROUBLED ARTS ORGANIZATIONS**

How can one create and maintain a healthy arts organization despite
economic constraints inherent in the industry?

Michael M. Kaiser has revived four major arts organizations: the
Kansas City Ballet, the Alvin Ailey American Dance Theater,
American Ballet Theatre, and London's Royal Opera House. In
The Art of the Turnaround he shares with readers his ten basic rules
for bringing financially distressed arts organizations back to life
and keeping them strong. These rules cover the requirements for
successful leadership, the pitfalls of cost cutting, the necessity of
extending the programming calendar, the centrality of effective
marketing and fund raising, and the importance of focusing on the
present with a positive public message. Kaiser brings his ten rules
vividly to life in discussions of the four arts organizations he is
credited with saving. The book concludes with a chapter on his
experiences at the John F. Kennedy Center for the Performing Arts,
an arts organization that needed an artistic turnaround when he
became the president in 2001 and that today exemplifies in practice
many of the ten rules he discusses throughout his book.

BRANDEIS UNIVERSITY PRESS

Published by University Press of New England

ISBN 13: 978-1-58465-735-4

WWW.UPNE.COM

"[An] extraordinary book that serves as both cautionary tale and practical primer in crisis response. ... Whether you are serving in an entry level or executive leadership position, from crew chief to executive director, there is much to be learned in Michael Kaiser's *The Art of the Turnaround*."
—*Theatre Design & Technology*

"[A] must-read in the arts world."
— *Sacramento Bee*

"For any arts executive or program staffer interested in learning how to revive the fortunes of an ailing organization — or build on the success of a healthy one — *The Art of the Turnaround* by Michael M. Kaiser is a must read."
—*Philanthropy News Digest*

"The Kennedy Center and Michael Kaiser offered swift, constructive, hands-on, and inspirational assistance during the crisis for the Louisiana Philharmonic Orchestra following Hurricane Katrina. We are still following and implementing planning done during that critical period and have been amazed at the hard work and resilience of our organization and our cultural community that was aided by this special partnership."
— BABS MOLLERE, Managing Director, Louisiana Philharmonic Orchestra

"That Michael Kaiser, along with his senior Kennedy Center administrators, are freely putting themselves at the service of the nation's arts organizations is an amazingly generous offer, made at a very important juncture. Michael Kaiser's advice and expertise have been a tremendous help to City Opera. I strongly encourage other arts organizations in these challenging times to avail themselves of this exceptional team of experts."
— SUSAN BAKER, Chairman, New York City Opera Board

"When DTH had to close its doors because of financial difficulties, we worked with Michael Kaiser on a strategic plan, assessing the organization's strengths and weaknesses, reorganizing the board, and placing the organization on a solid administrative footing in order to support the organization's artistic vision. His assistance helped us reopen in just six weeks."
— LAVEEN NAIDU, Executive Director, Dance Theatre of Harlem